TUCSON
IMPRESSIONS

FARCOUNTRY
PRESS

photography by **James Randklev**

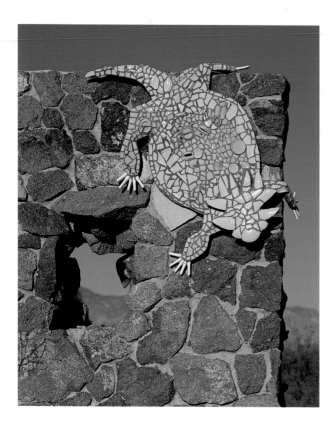

Left: A lizard mosaic adorns the Santa Cruz River Parkway, which is popular with runners and bicyclists.

Right: Sculpture at the Richard and Annette Bloch Cancer Survivors Plaza in Reid Park. Located in the center of town, the park features a lake, baseball fields, and zoo that is home to more than 400 mammals, reptiles, and birds.

Title page: Amid the cholla and blooming ironwood stands the saguaro cactus, which is found only in the Sonoran Desert.

Front cover: This wrangler pauses to enjoy the saguaro cacti and mountains surrounding the 160-acre Lazy K Bar Guest Ranch, which was established in 1936 on lands bordering 24,000-acre Saguaro National Park.

Back cover: Hollyhocks and a prickly pear cactus frame a doorway in Tucson's Barrio Historico district.

ISBN 13: 978-1-56037-344-5
ISBN 10: 1-56037-344-X
Photography © 2005 by James Randklev
© 2005 Farcountry Press

For more information about our books write Farcountry Press, P.O. Box 5630, Helena, MT 59604; call (800) 821-3874; or visit www.farcountrypress.com.

Created, produced, and designed in the United States.
Printed in China.

09 08 07 06 05 1 2 3 4 5

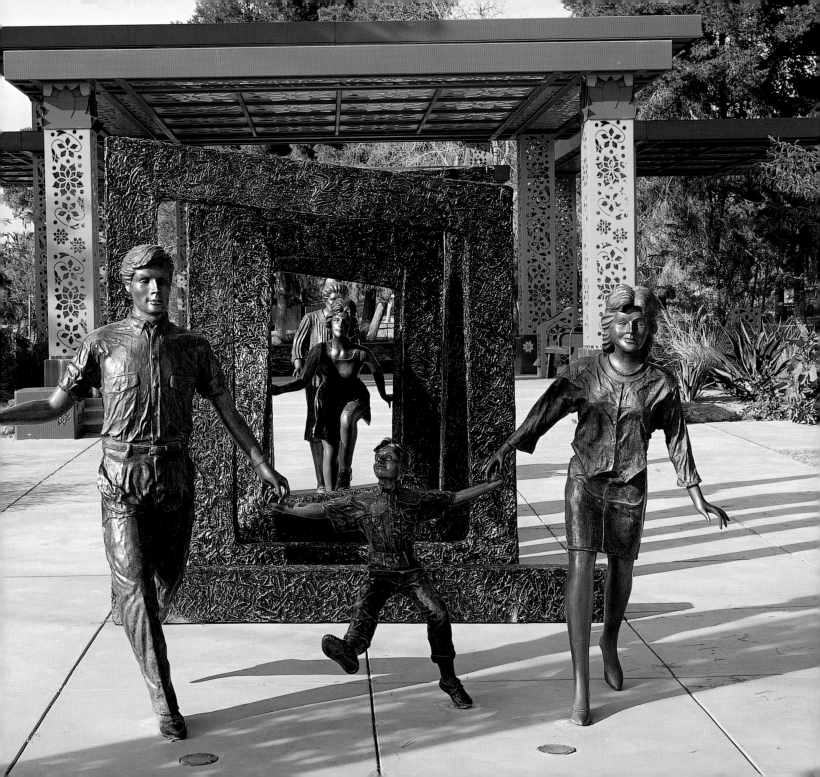

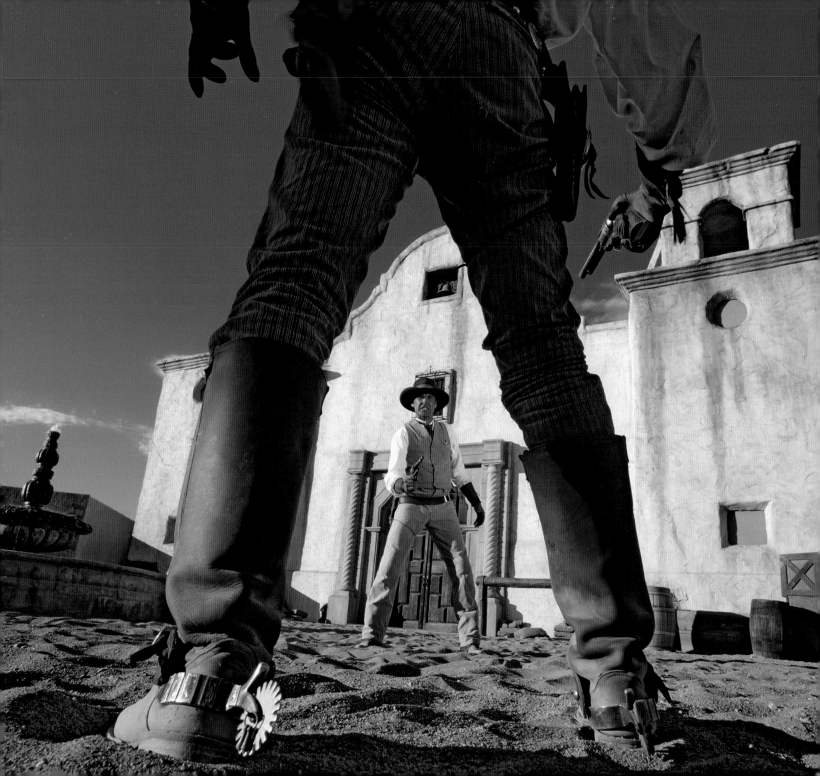

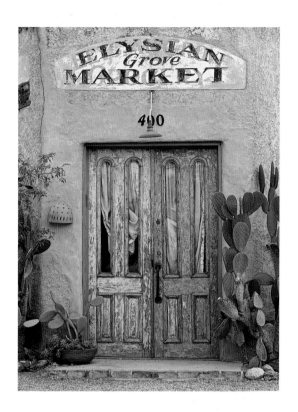

Left: The colorful doorway of the old Elysian Market, located in Tucson's Barrio Historico, reflects Tucson's Spanish and Mexican roots.

Facing page: Gunfighters stage a mock shootout at a re-creation of an 1880s Western town at the Old Tucson Studios. Hundreds of Hollywood major motion pictures were filmed at the studios, starring actors ranging from John Wayne to Harrison Ford. EDWARD McCAIN

Below: The DeGrazia Mission in the Sun is an adobe chapel that artist Ted DeGrazia created to honor Father Eusebio Francisco Kino and Our Lady of Guadalupe. Part of a ten-acre desert oasis at the foot of the Santa Catalina Mountains, the DeGrazia gallery and mission are filled with the artist's paintings, water-colors, and sculptures. DeGrazia, who lived from 1909 to 1982, is known for his impressionistic paintings of Indian children.

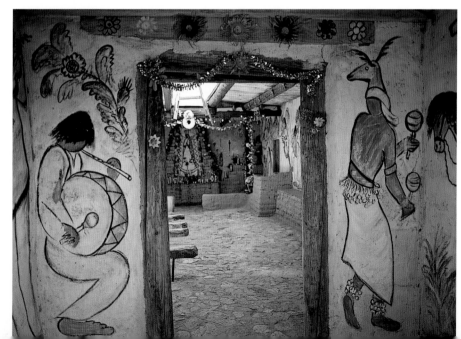

Right: The rock walls of the Aravaipa Canyon Wilderness are weathered and ancient. This area is composed of an 11-mile-long, 1,000-foot-deep trough and is known as the "gem of the Southwest."

Below: Tanque Verde Creek cuts through the canyon of the same name in the 1,780,000-acre Coronado National Forest in southeastern Arizona. The creek's waterfalls pour into pools that are popular swimming spots for locals.

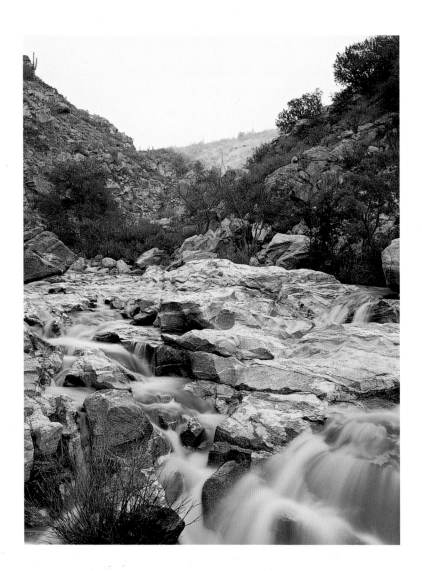

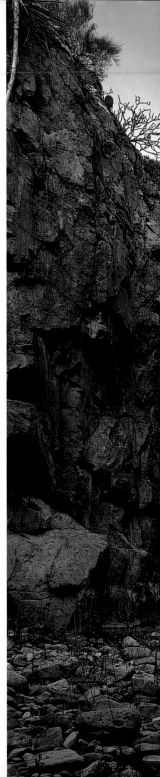

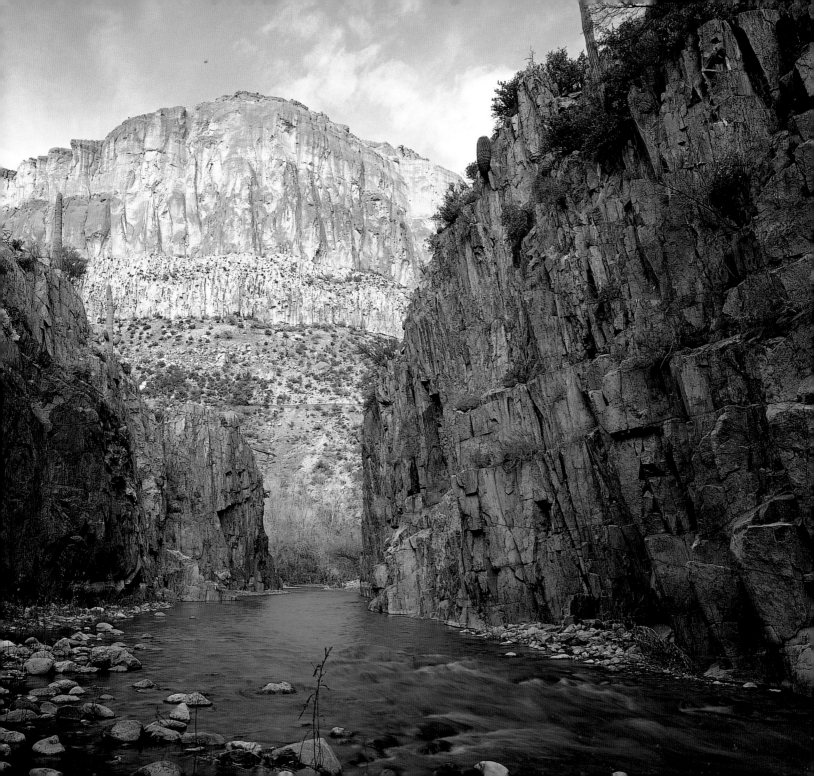

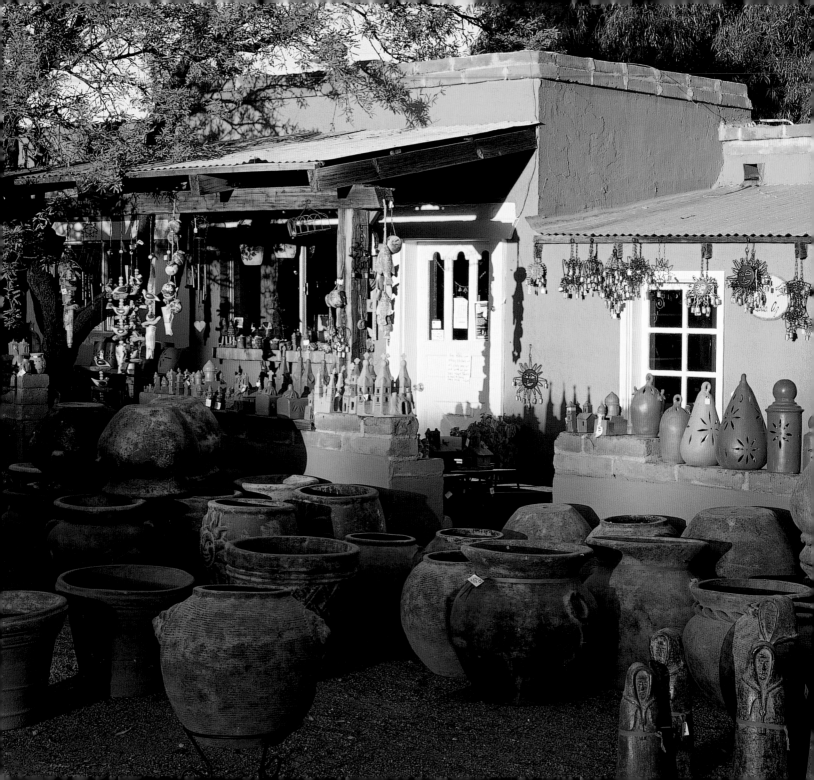

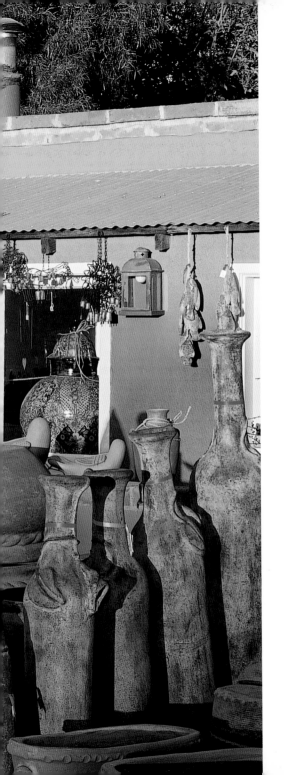

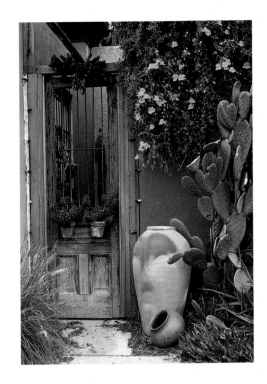

Left: Fountain grass and prickly pear cactus frame a doorway in Tucson's varied and culturally diverse downtown historic district.

Far left: Artist studios, such as this one, surround the grounds that once served as the home for a Spanish military garrison in Tubac, which was established in 1752 as a Spanish presidio or fort.

Below: In a state where cattle once outnumbered people, the cattle skull has become the long-time symbol of Arizona.

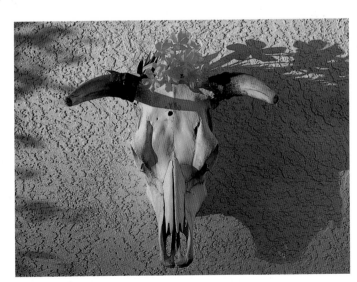

Right: A rainbow arcs over blooming ocotillo plants in the West Tucson Mountains in a 2,000-acre Sonoran Desert natural preserve west of town.

Below: A couple enjoys a relaxed moment on a patio at the Spanish colonial-style Hacienda del Sol Guest Ranch Resort in the foothills of the Santa Catalina Mountains. Established as a girls' school in 1929, the facility became a guest ranch and Hollywood hideaway in the 1940s, frequented by the likes of Spencer Tracy, Katharine Hepburn, and Clark Gable.

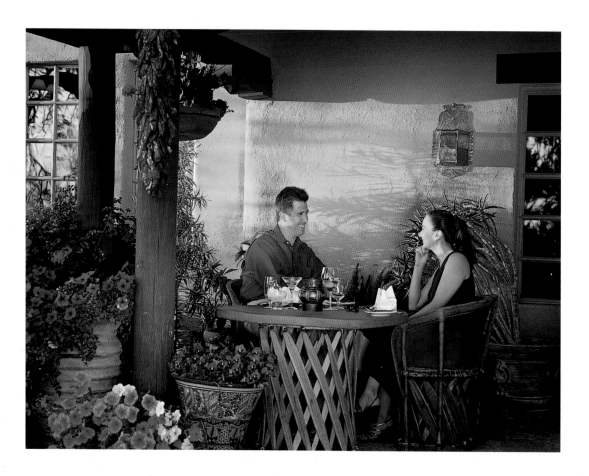

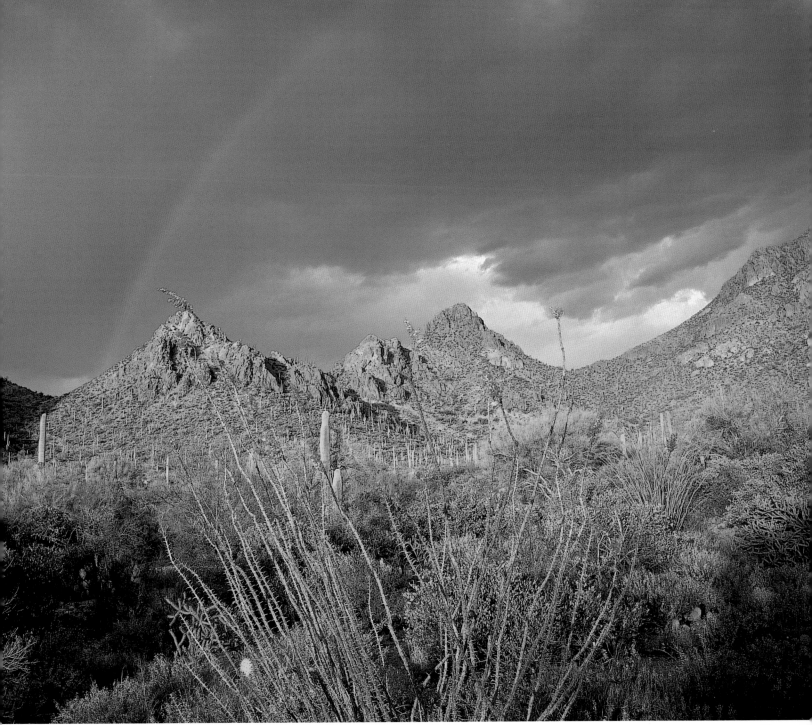

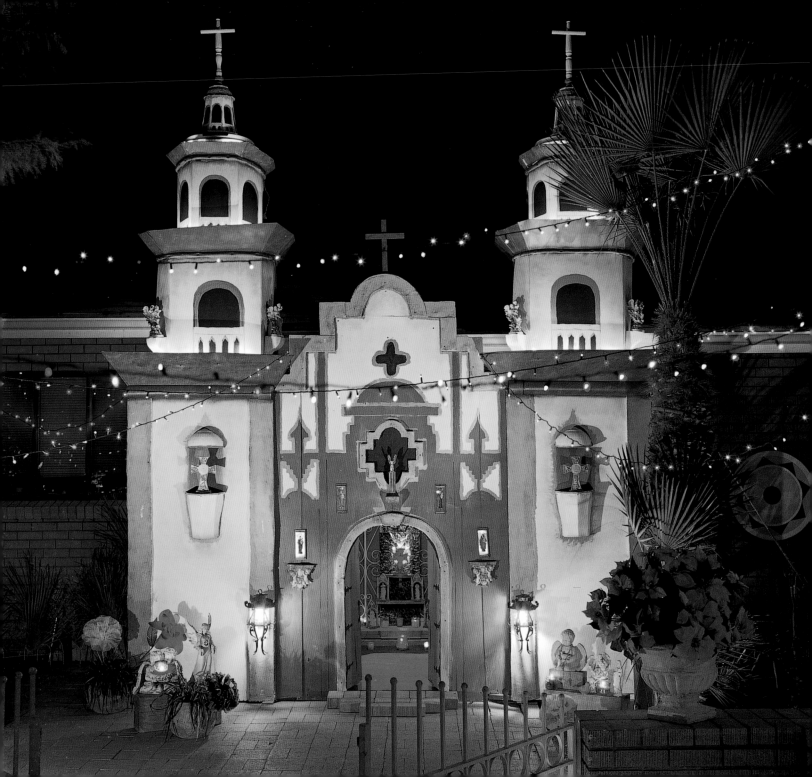

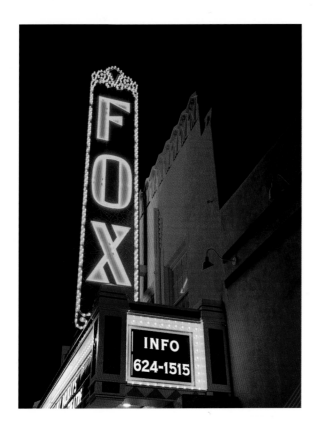

Above: Built in 1929, the Fox Theatre was once the entertainment center of downtown Tucson. Designated a National Historic Site in 2004, the theatre is undergoing an estimated $11 million renovation.

Right: The Hotel Congress was built in 1919 to serve the growing cattle and railroad industries.

Facing page: Since 1949, the people of Winterhaven have participated in a Christmas decorating contest with categories such as best rooftop, best Southwestern theme, and best cowboy theme.

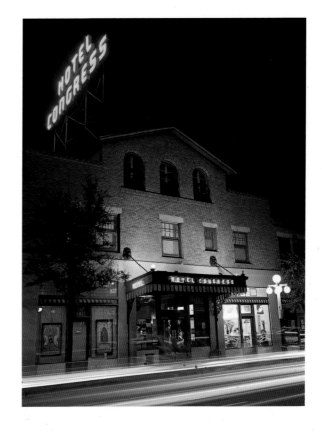

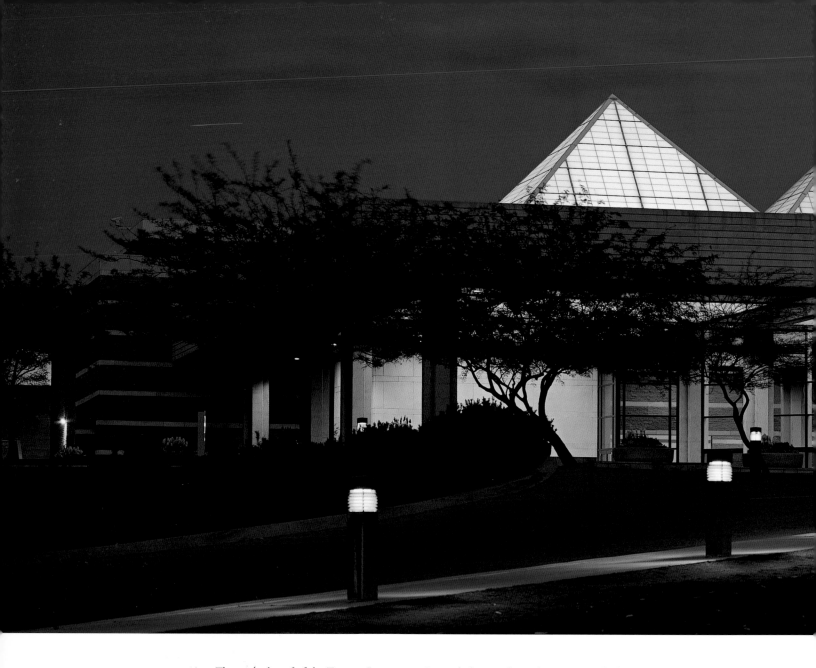

Above: The peaked roof of the Tucson Convention Center lights up the night. Sporting the largest arena in southern Arizona, a music hall, and the Leo Rich Theatre, the center hosts events ranging from circuses to operas.

Inset: The unique entrance to Longhorn Grill welcomes diners in Amado, along Highway 19 south of Tucson.

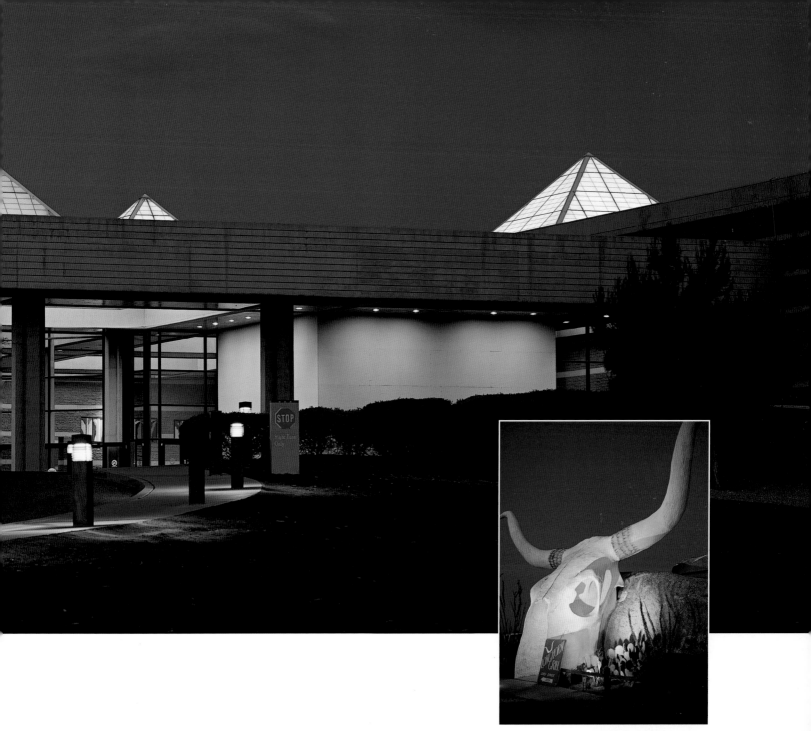

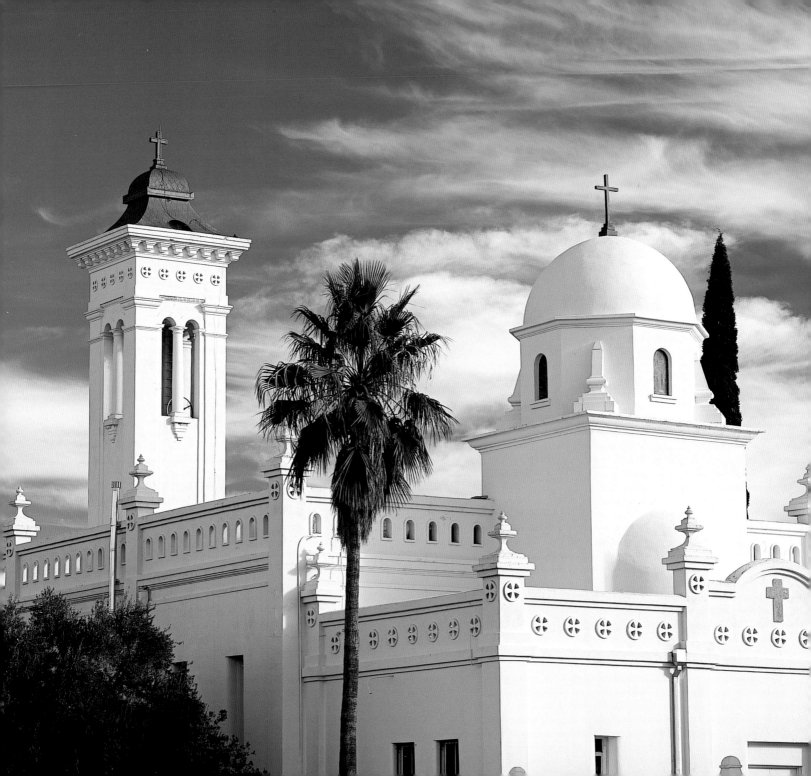

Left: The predominantly Hispanic Santa Cruz Catholic Church is situated on the corner of Sixth Avenue and Twenty-Second Street.

Below: This docent holds a Harris hawk for visitors to see at the Arizona–Sonora Desert Museum, a twenty-one-acre facility featuring a natural history museum, zoo, and botanical gardens with more than 1,200 plant varieties.

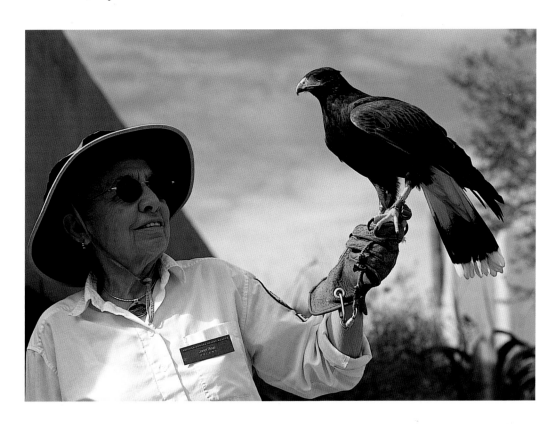

Above: Bats dwell in these bat houses and are just a few of the 300 animal species at the Arizona–Sonora Desert Museum.

Right: Saguaro cacti dot Pusch Ridge in the Oro Valley, formed by the Santa Cruz River and Gold Creek and situated at the base of the 9,000-foot Santa Catalina Mountains.

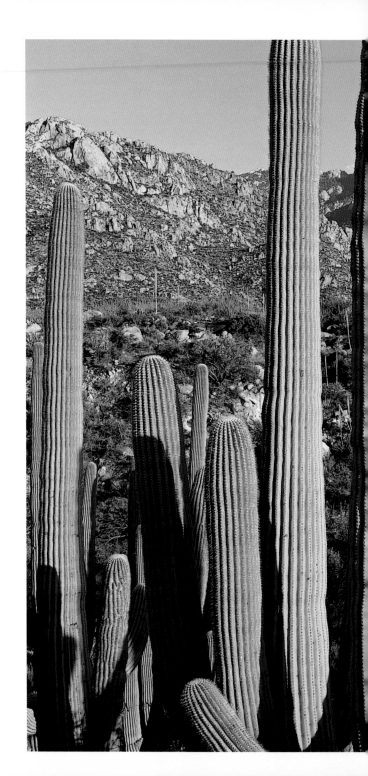

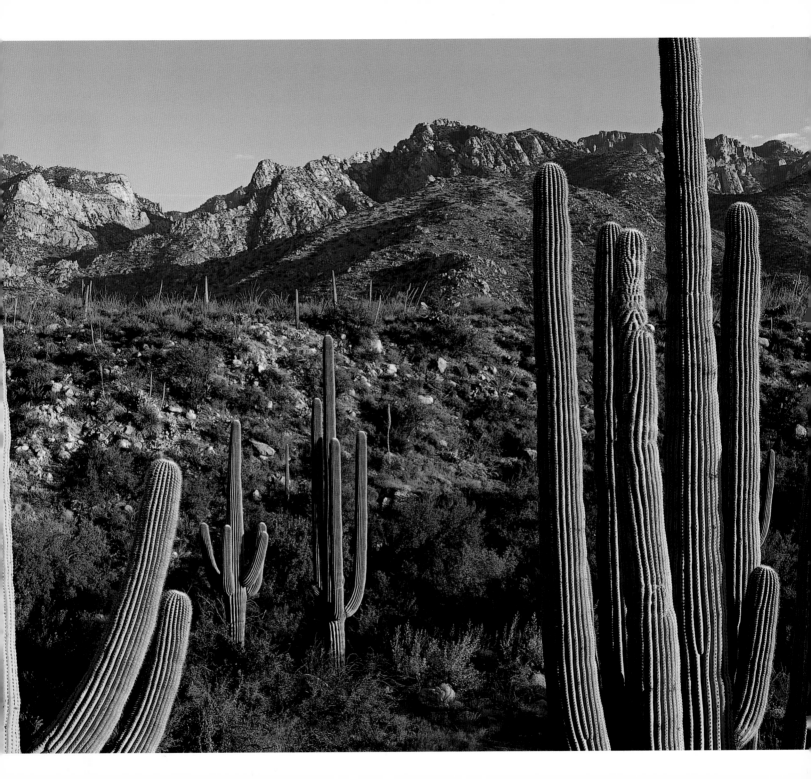

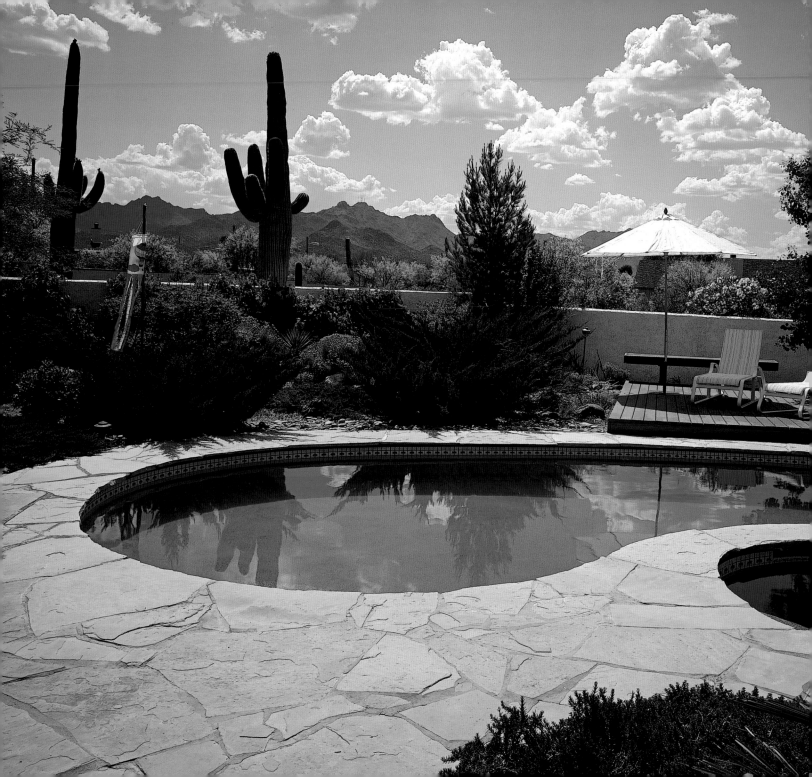

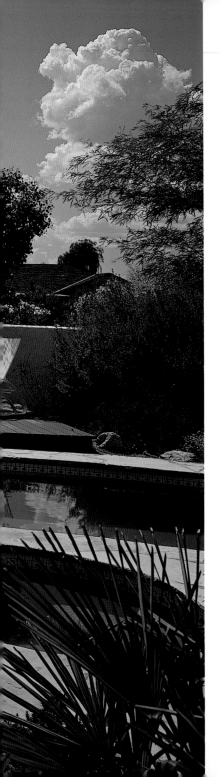

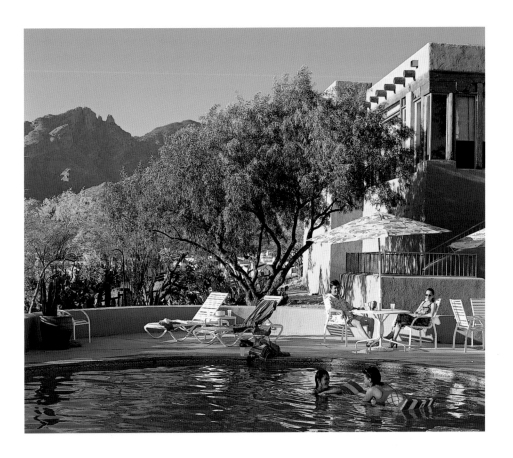

Above: Guests enjoy the pool at the Hacienda del Sol Guest Ranch Resort. Surrounded by thirty-four acres of desert, the resort boasts thirty guests rooms ranging from courtyard rooms to the Casita Grande, which was rumored to be the secret hideaway of movie stars Katherine Hepburn and Spencer Tracy.

Left: This pool—a popular item in town, where summer temperatures can soar to 100 degrees—is bordered by saguaro cacti and the mountainous Tucson skyline.

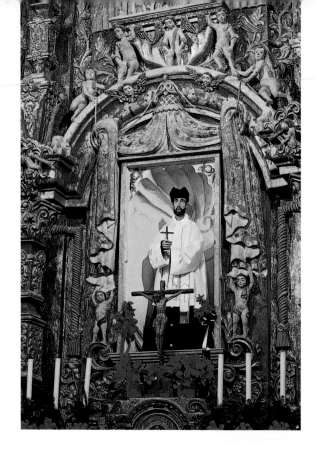

Left: This intricately carved altar is located inside the Mission San Xavier del Bac, which is known as the White Dove of the Desert.

Facing page: The Mission San Xavier del Bac, located in the Santa Cruz Valley, is a fine example of mission architecture. Founded in 1700, this structure was built in 1791 by Franciscan Fathers Juan Bautista Velderrain and Juan Bautista Llorenz.

Below: This statue of the Virgin Mary was created in 1790. Although the mission's original artisans are unknown, it is believed that many came from the local Tohono O'odham settlement.

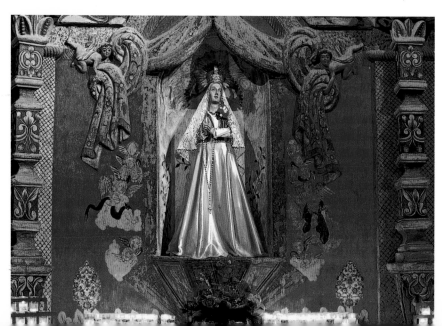

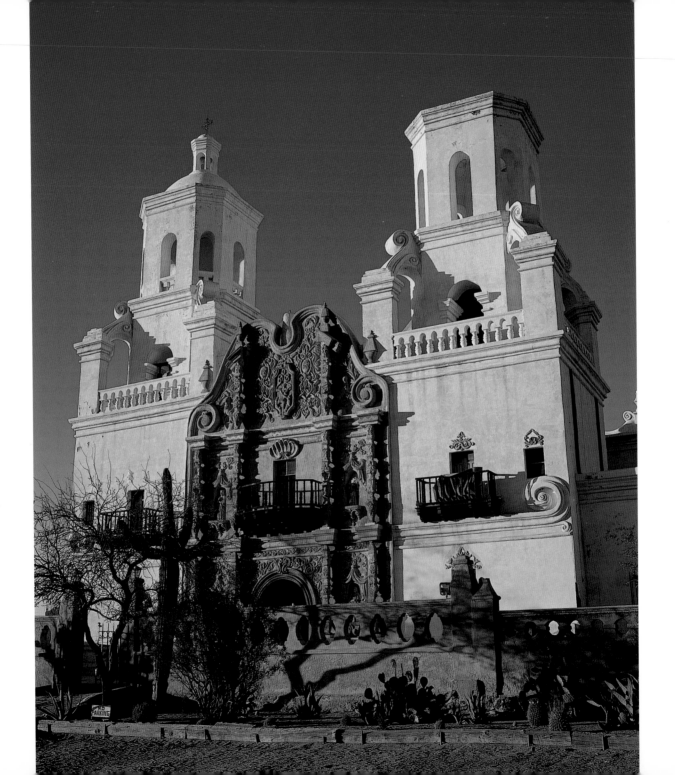

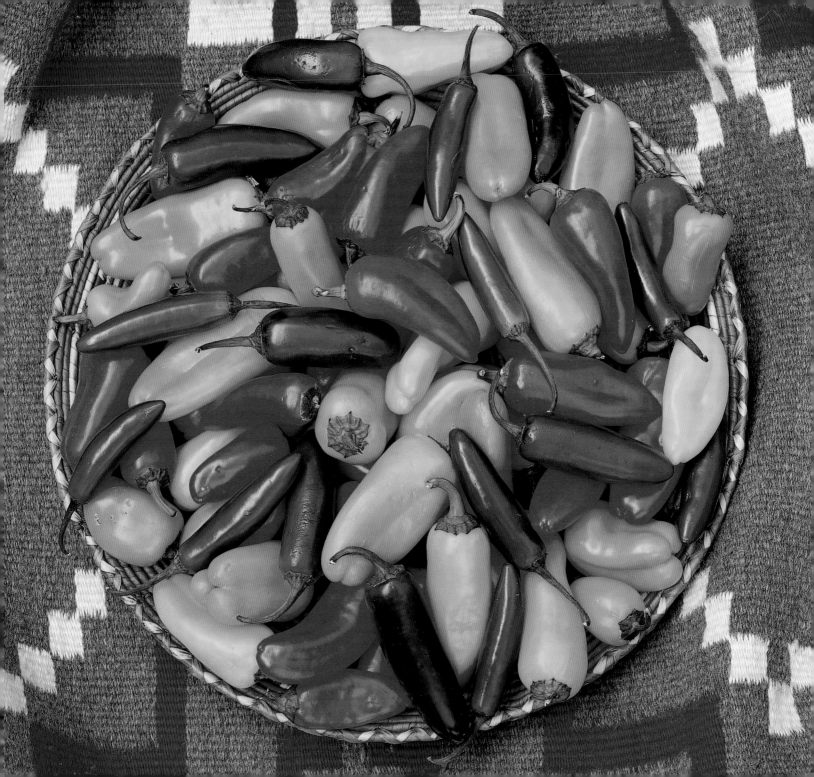

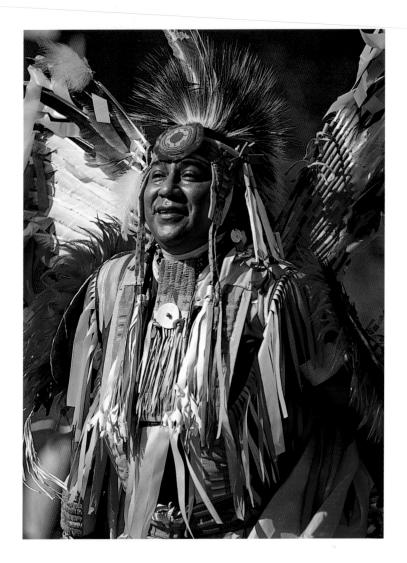

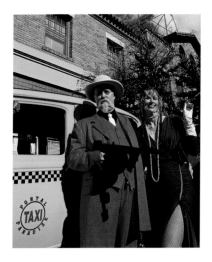

Above: An intertribal dancer performs at Dillinger Days, hosted by the Hotel Congress in downtown Tucson, which celebrates the January 22, 1934, capture of the criminal John Dillinger. Two local firemen recognized and caught Dillinger, who was carrying heavy bags loaded with firearms and $23,816 in cash.

Above right: During the Dillinger Days celebration, locals portray 1930s gangsters and floozies.

Facing page: This array of chiles—including Anaheim, banana, Fresno, and jalapeño chiles—are staple ingredients in Southwestern cuisine.

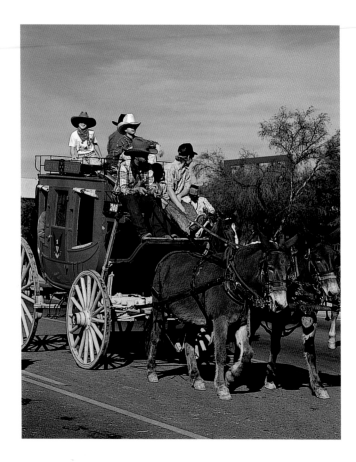

Facing page: This young dancer from the Lajkonik Polish dance group is part Tucson's Family Arts Festival, which features entertainment ranging from Middle Eastern dancers to Hungarian folk musicians.

Below: More than 200 Mexican folk dancers, cowboys, floats, historic horse-drawn carriages, and marching bands participate in the annual La Fiesta de los Vaqueros.

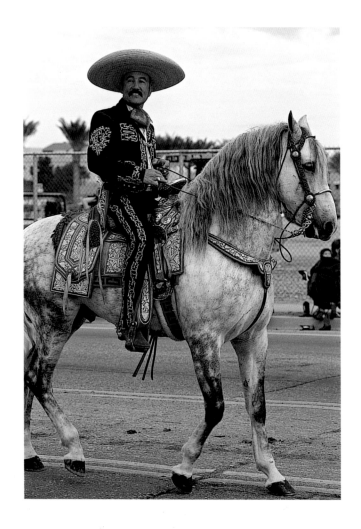

Above: Although the original 1925 La Fiesta de los Vaqueros rodeo parade (or "celebration of the cowboy") was thought by locals to be too pretentious, today 200,000 spectators line the streets to watch the festivities.

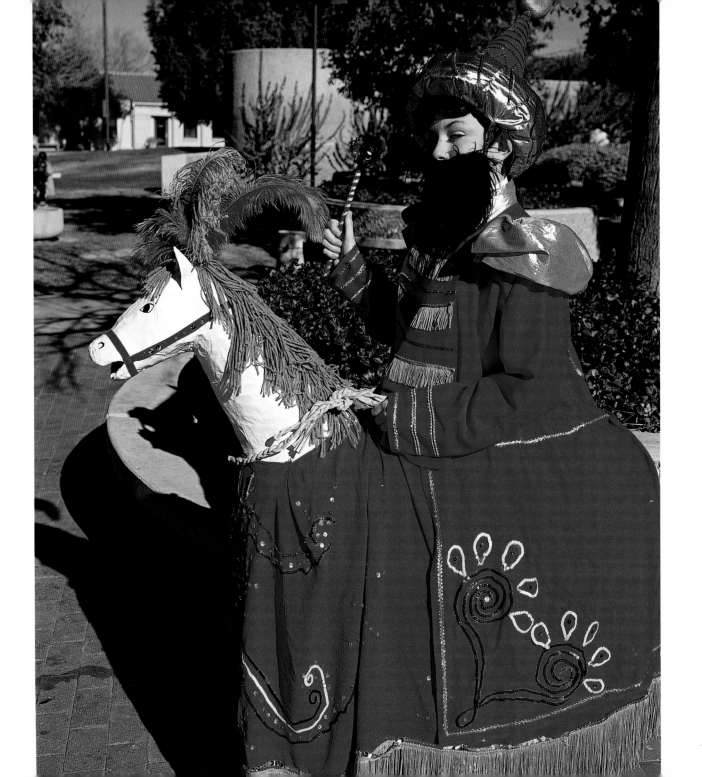

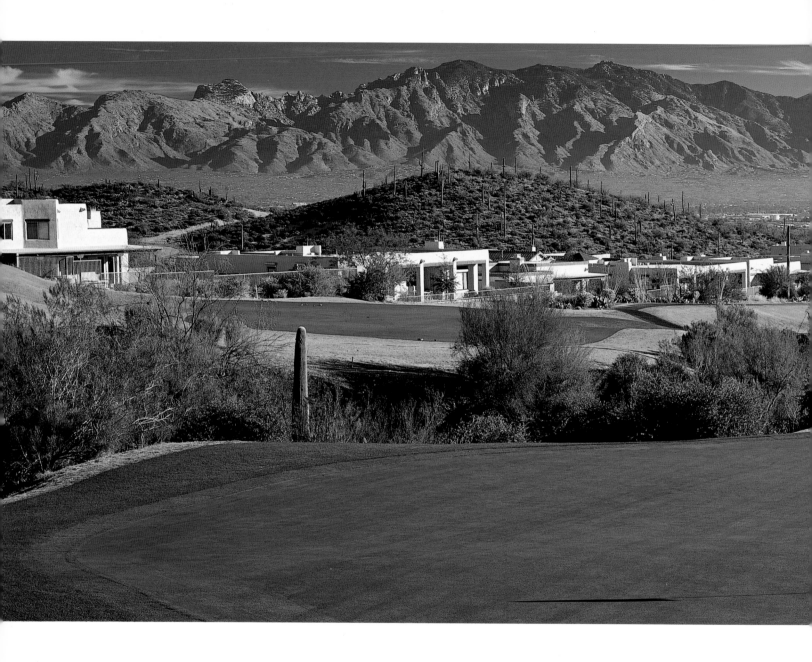

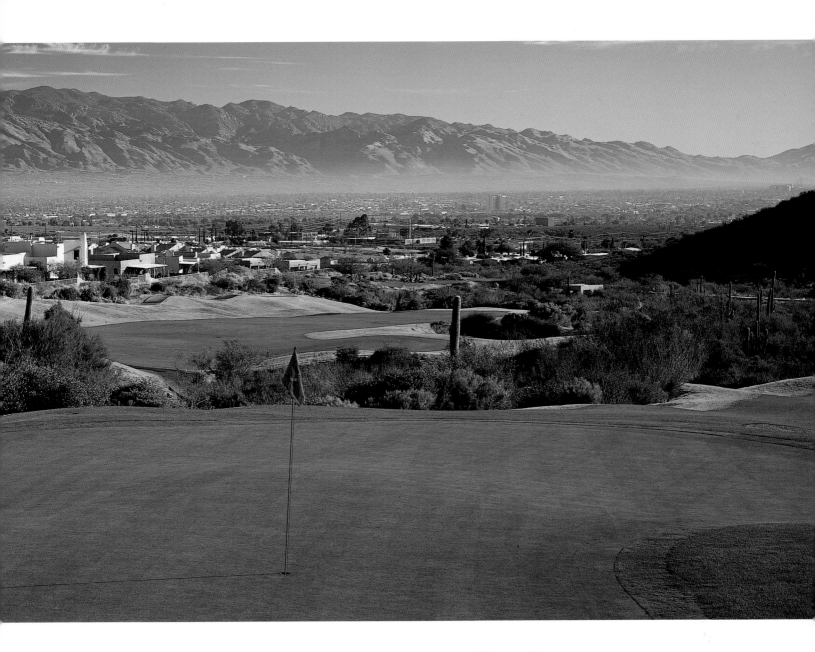

The fairway at the thirty-six-hole Starr Pass golf course. This Arnold Palmer signature golf course offers an excellent view of the five mountain ranges surrounding Tucson.

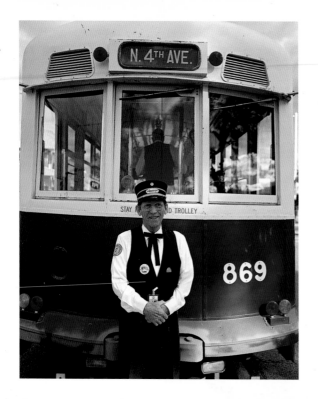

Left: Locals and visitors enjoy riding the Fourth Avenue Street Trolley that runs from the University district to downtown.

Right: In addition to their serene natural beauty, private water gardens provide a wildlife oasis in Tucson's Sonoran Desert landscape.

Below: Trails wind through the forty-nine-acre desert preserve at Tohono Chul Park. The park was dedicated in 1985 by founders Richard and Jean Wilson, who wanted to preserve something natural in the middle of the surrounding development.

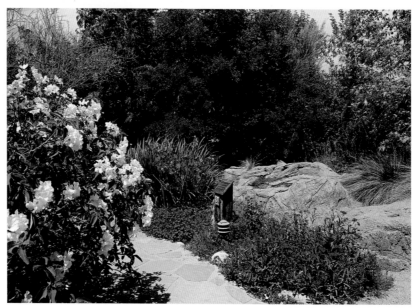

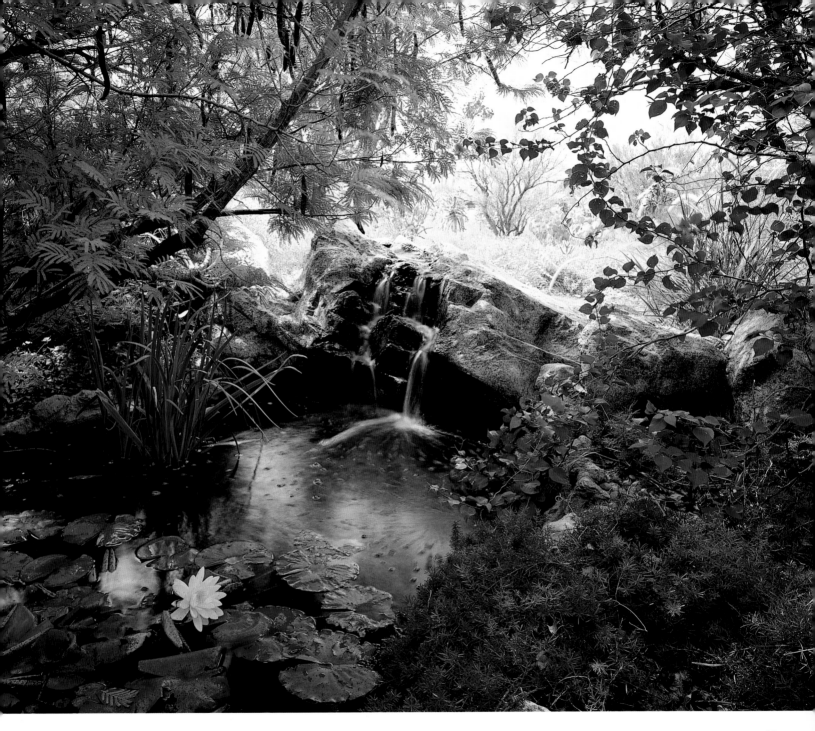

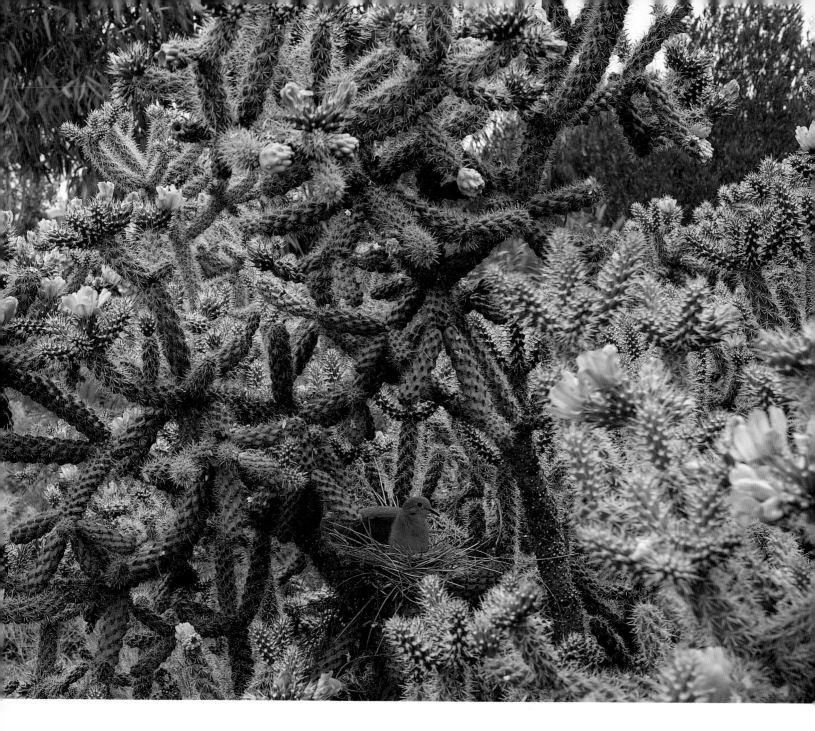

Facing page: This blooming cholla cactus provides a safe haven for a mourning dove's nest in Saguaro National Park.

Below: A giant saguaro cactus reaches skyward at daybreak in Finger Rock Canyon. Saguaros can live up to 150 years, grow as high as 50 feet, and weigh as much as 10 tons.

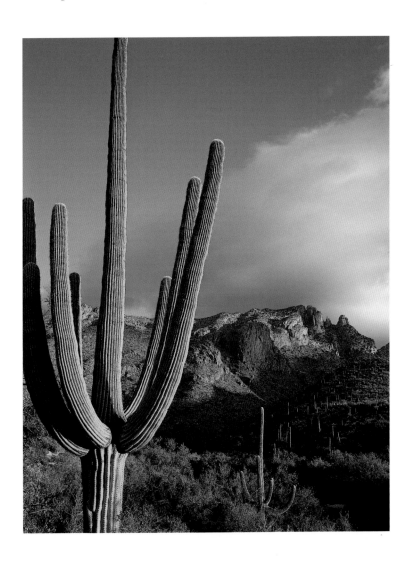

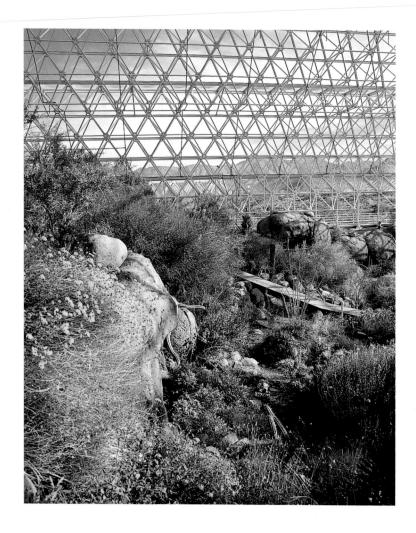

Above: Plants thrive in the desert biome, one of five different biomes that are self-sustaining communities at Biosphere 2, located thirty miles north of Tucson.

Right: Designed as a steel-and-glass, airtight replica of the earth's environment, Biosphere 2 features a desert, as well as a rainforest, agricultural area, human habitat, and 900,000-gallon ocean.

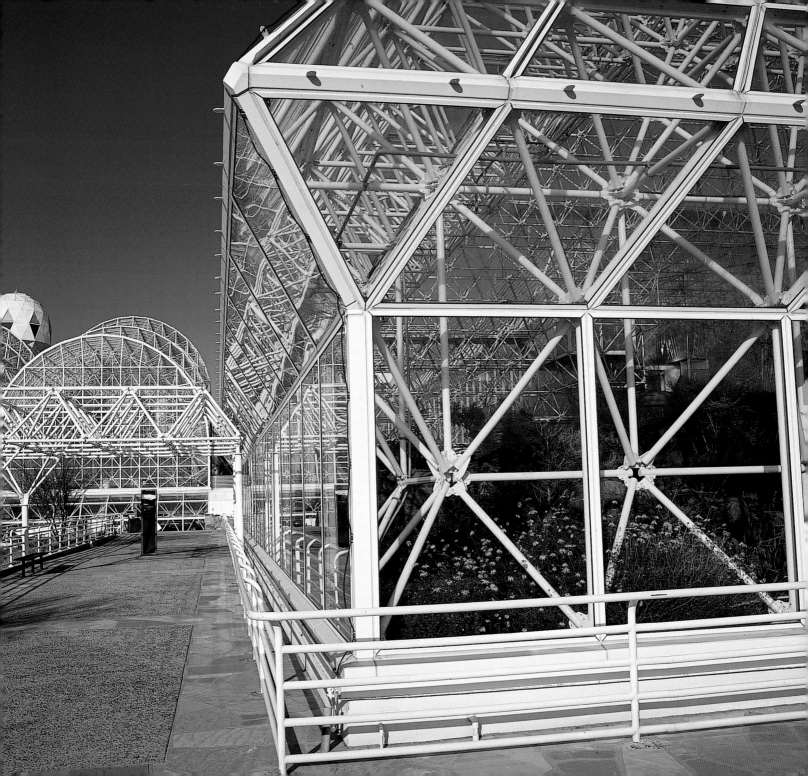

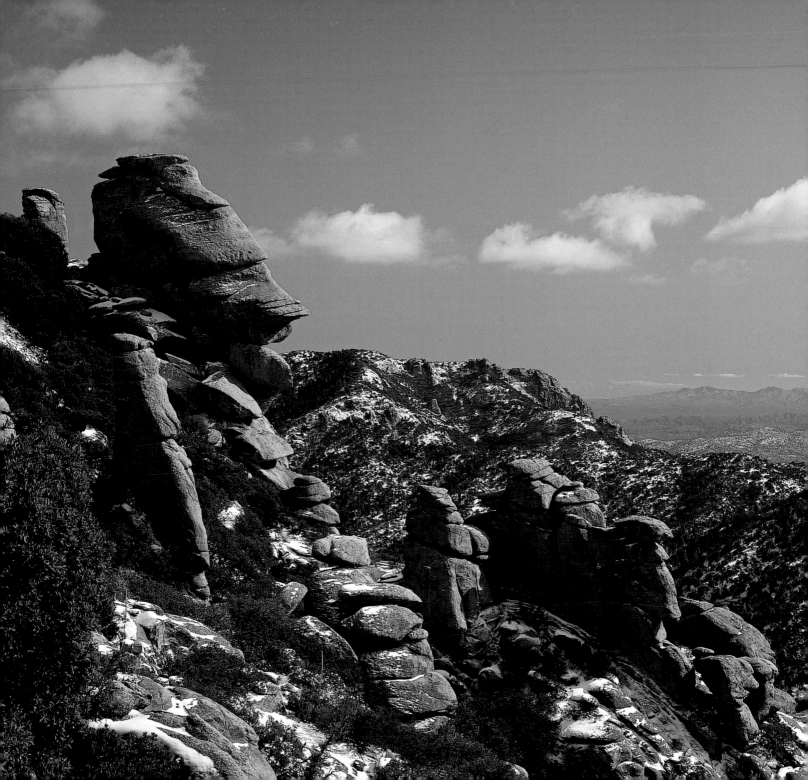

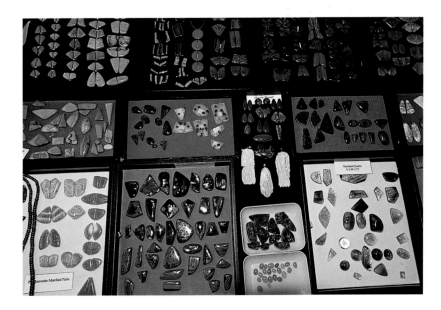

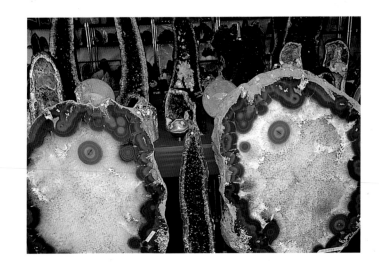

Above: Fine cut stones, including turquoise and malachite, are showcased at the Tucson Gem and Mineral Show, which features more than 200 gem, jewelry, and fossil dealers.

Right: Giant cut agates are on display at the Tucson Gem and Mineral Show.

Left: Windy Point rock formations seem to gaze toward the Santa Catalina Mountains in the 1.8-million-acre Coronado National Forest, where elevations climb from 3,000 to 10,720 in twelve scattered mountain ranges.

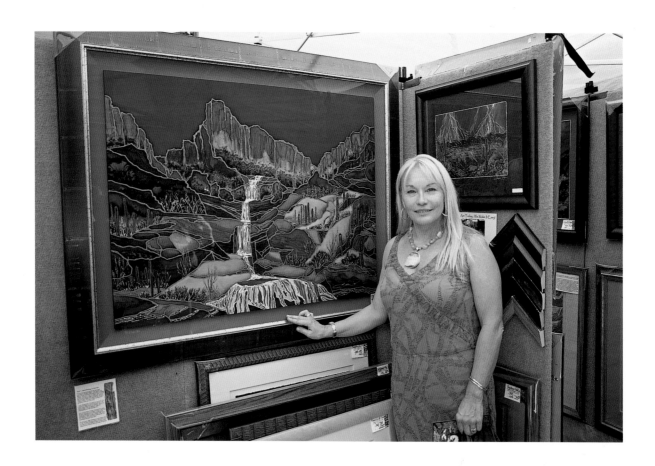

Above: Award-winning artist Linda Pirri exhibits her unique paintings on silk at Tucscon's semi-annual Fourth Avenue Street Fair. Started by area merchants, the three-day fair features more than 400 arts-and-crafts booths, as well as numerous food vendors, street musicians, and performers.

Facing page: Tucson's 1928 Pima County Courthouse, a blend of Southwestern, Spanish, and Moorish architectural styles, also features a display of adobe bricks from the original presidio wall built in the 1700s.

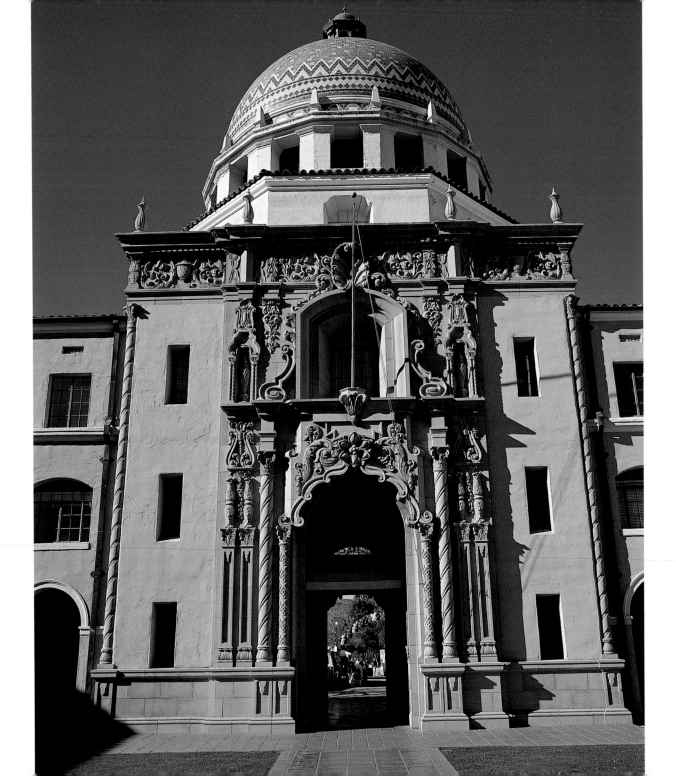

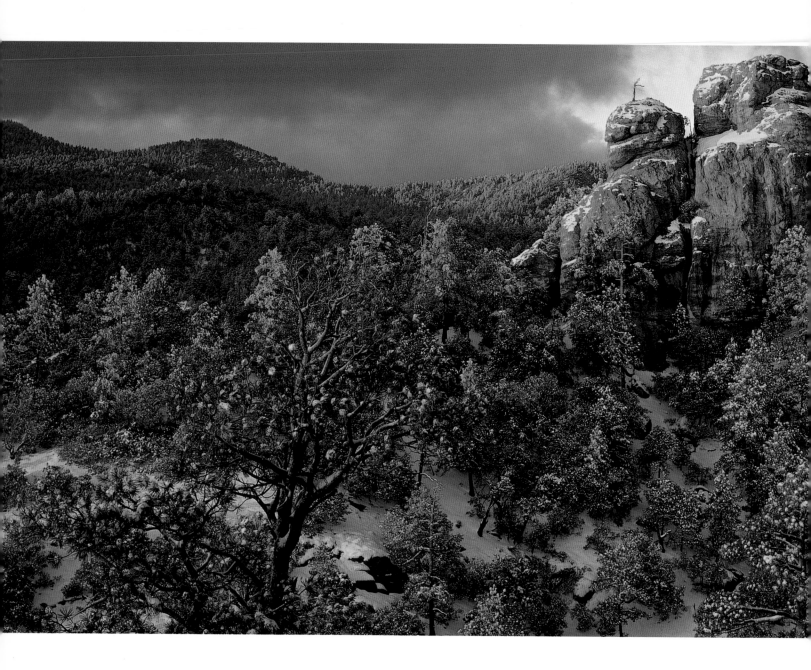

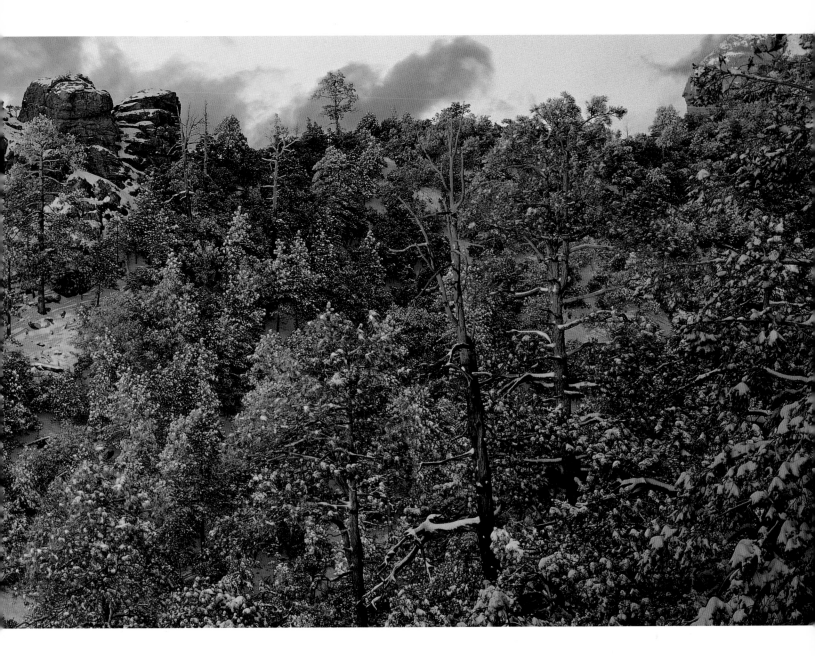

Snow blankets pines along Mount Lemmon Highway in the Santa Catalina Mountains. Because elevations rise dramatically from the desert floor to mountain sky islands in the Coronado National Forest, visitors can experience all four seasons in a day.

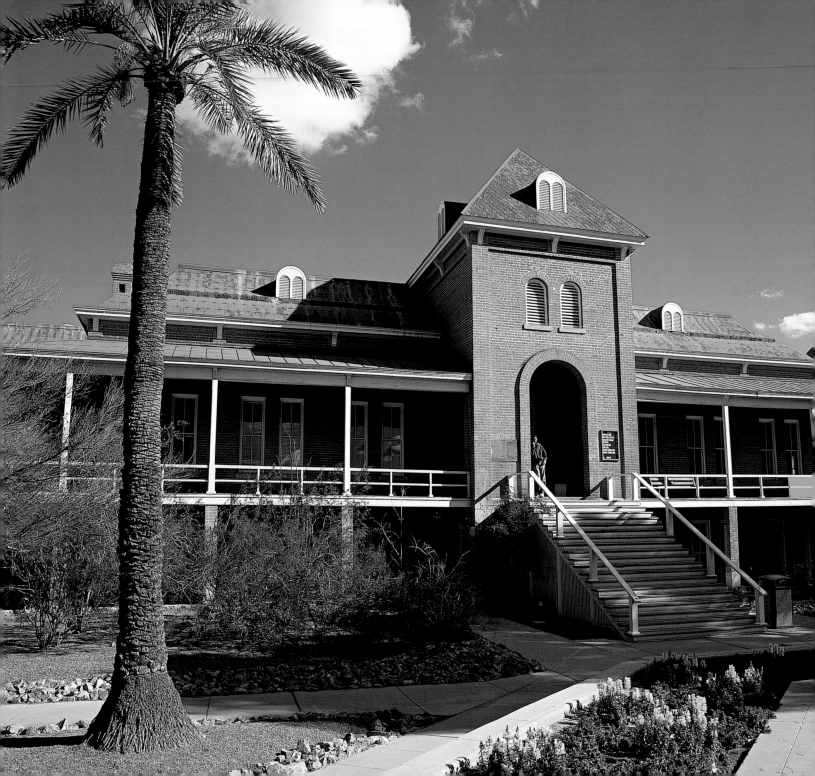

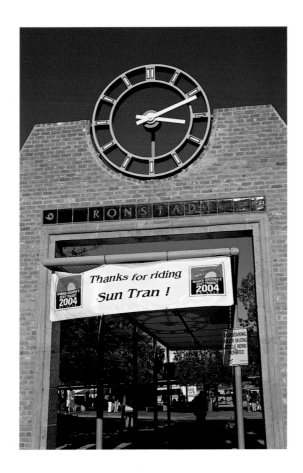

Below: Arizona State Museum, which features a large collection of Southwest pottery, was one of Southwest's first anthropological museums when it was established in 1893 on the University of Arizona campus.

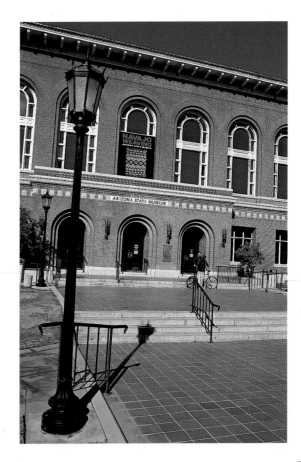

Above: The Ronstadt Transit Center was built on the site of the F. Ronstadt store that sold harnesses, saddles, and wagons at the turn of the century.

Left: Old Main was the first building constructed on the University of Arizona campus in 1887 on land owned by two professional gamblers, E. B. Gifford and Ben C. Parker. It has become the icon for the university.

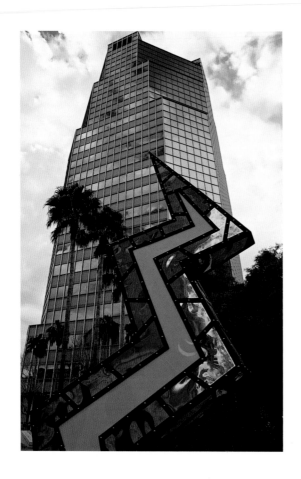

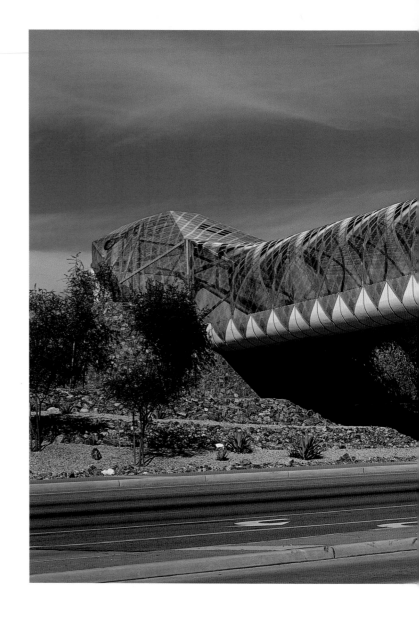

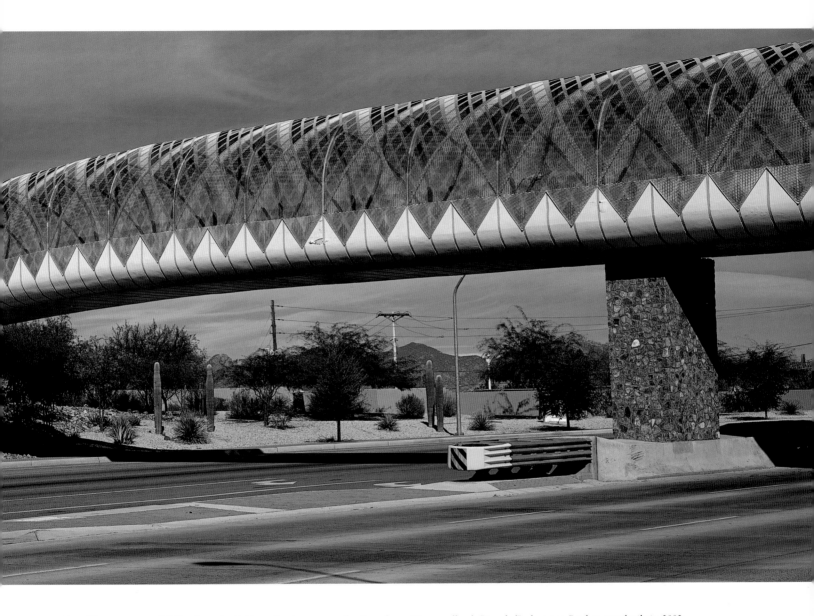

Above: The controversial Rattlesnake Bridge, also known as the Broadway Diamondback Bicycle/Pedestrian Bridge, was built in 2002. Designed by Simon Donovan, the bridge is 11 feet tall and 280 feet long and has eyes that light up and a tail that rattles.

Left: Located in front of the Unisource Energy Building in downtown Tucson, this solar-powered luminaria entitled *Lightning Strikes* was created by Doug Shelton for the Luminarias del las Pueblos, a benefit for the Tucson-Pima Arts Council.

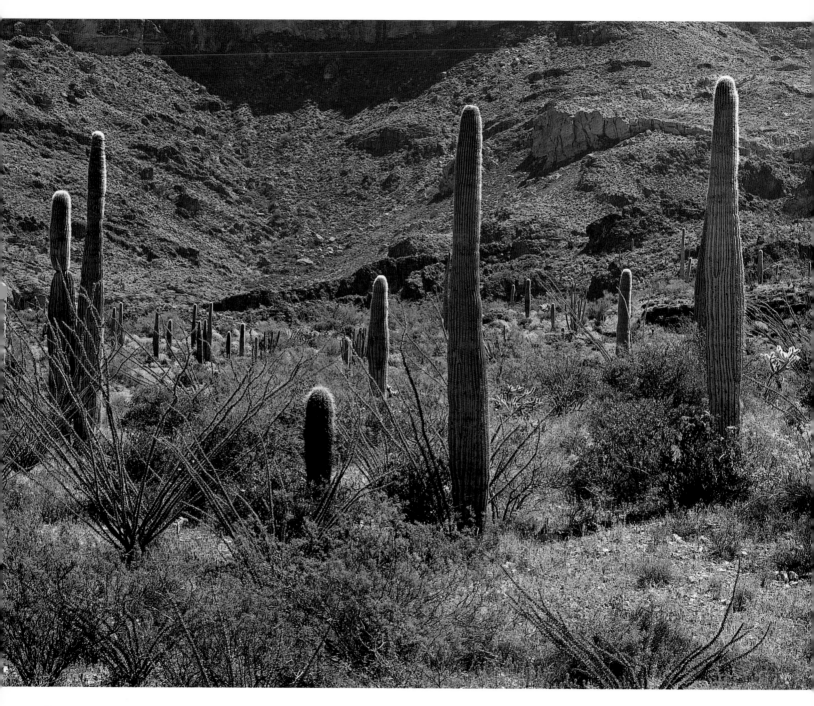

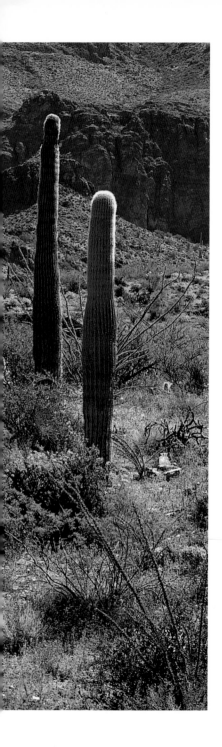

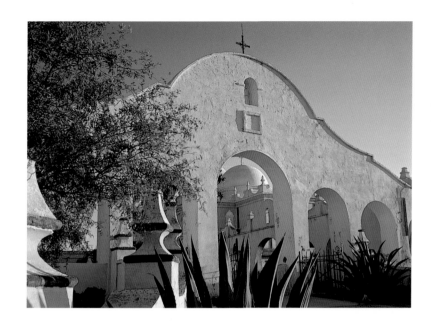

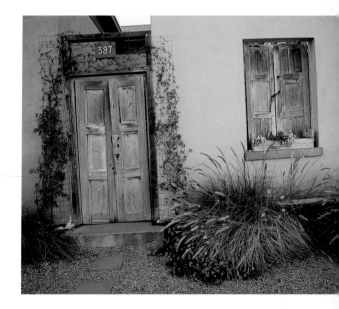

Above: Mission San Xavier del Bac, south of Tucson, was built in 1783 and features displays of historic clothing, books, and dishes.

Right: This street door and shuttered window are remniscent of the Spanish and Mexican architecture in Tucson's downtown historic district.

Left: Saguaros and owl's clover grow along Ajo Mountain Drive in Organ Pipe Cactus National Monument. Organ pipe and saguaros are two of the twenty-six species of cacti that thrive here in the hot, harsh Sonoran Desert.

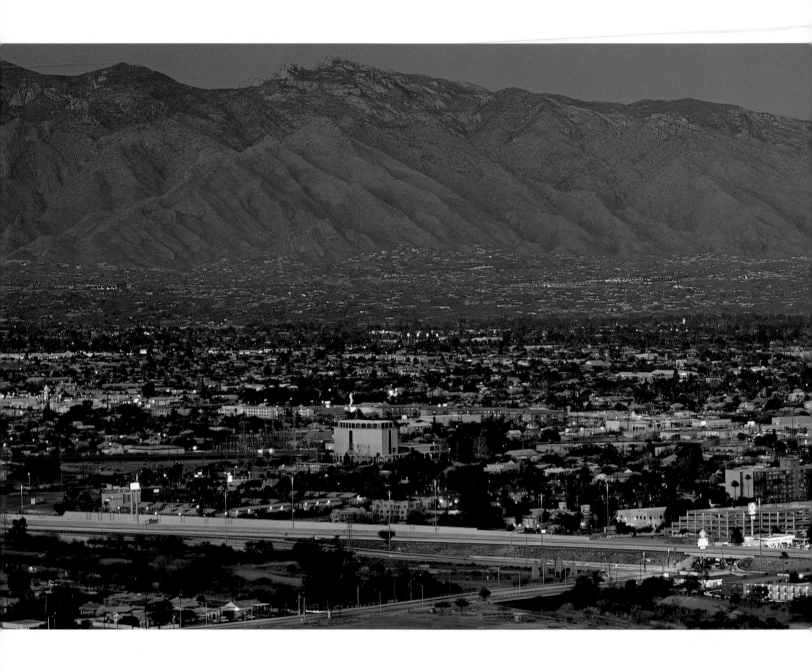

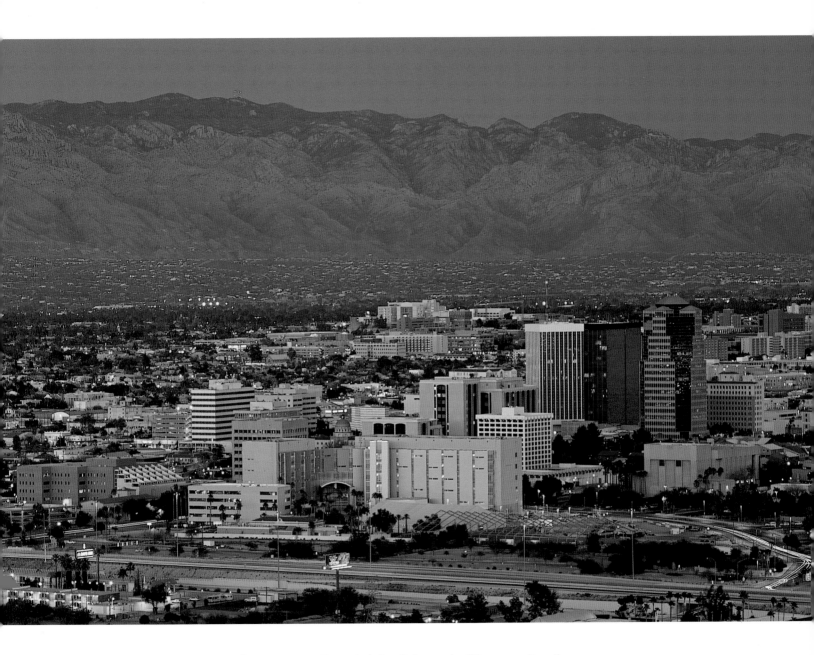

As twilight settles over the Santa Catalina Mountains, Tucson's skyline lights up the 500-square-mile valley.

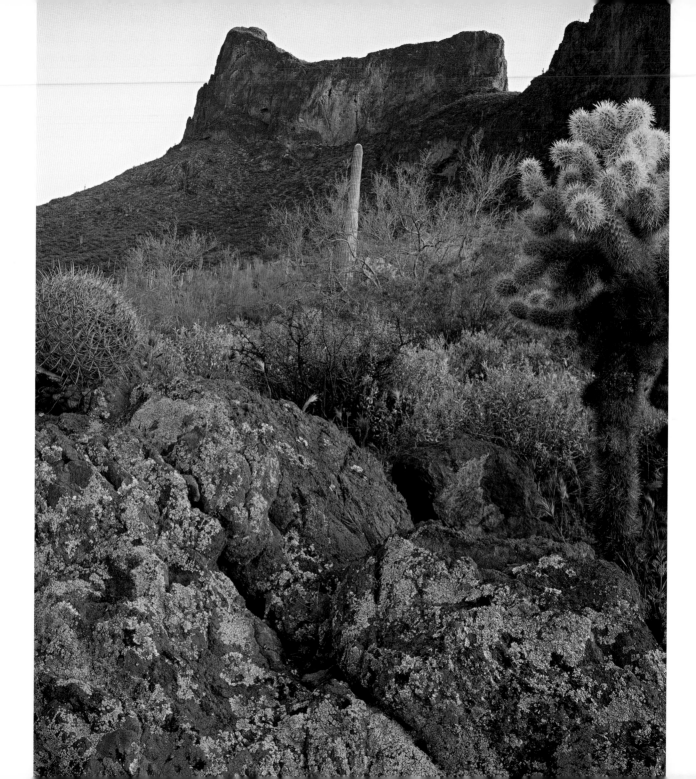

Facing page: In the 5,500-acre high-desert lands of Picacho State Park, fish hook and cholla cacti surround a lichen-covered rock.

Below: In springtime, tiny desert star flowers bloom in Saguaro National Park.

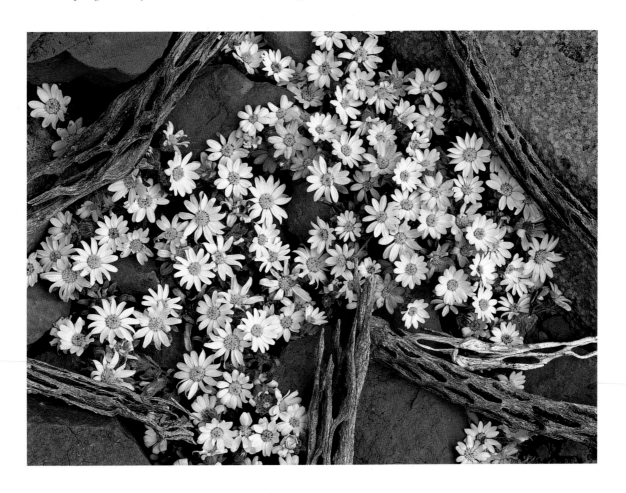

Facing page: A spring storm backlights ocotillo and giant saguaro cacti in Saguaro National Park.

Below: Colorful murals celebrating Tucson's history grace the walls of buildings throughout the town and are ever-changing.

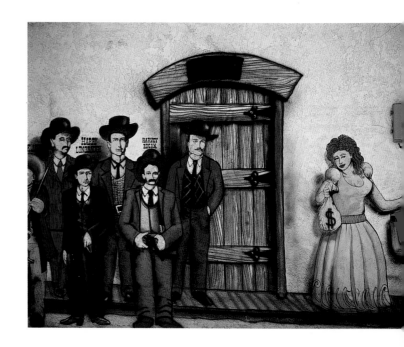

Above: Old Time Artisans, pictured above, is one of many Tucson shops that feature artwork, pottery, jewelry, and clothing by Southwestern artists.

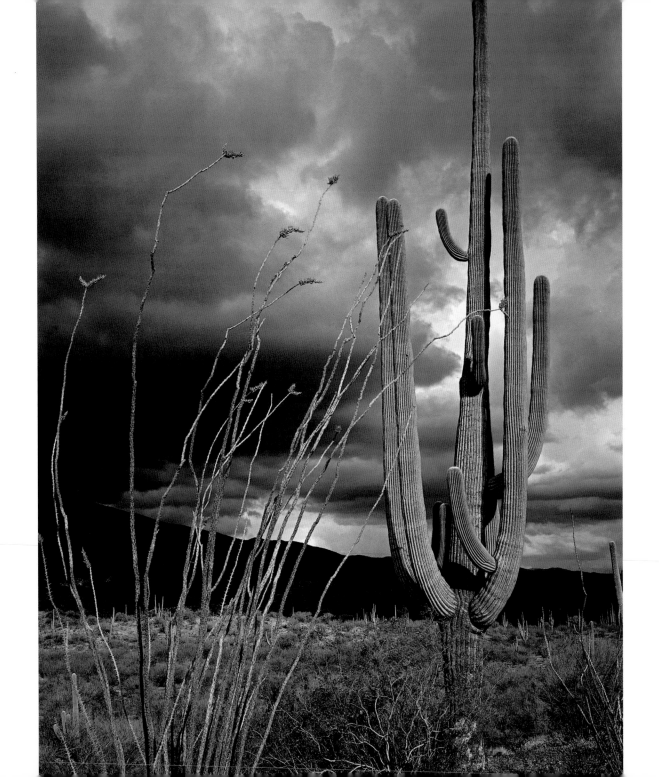

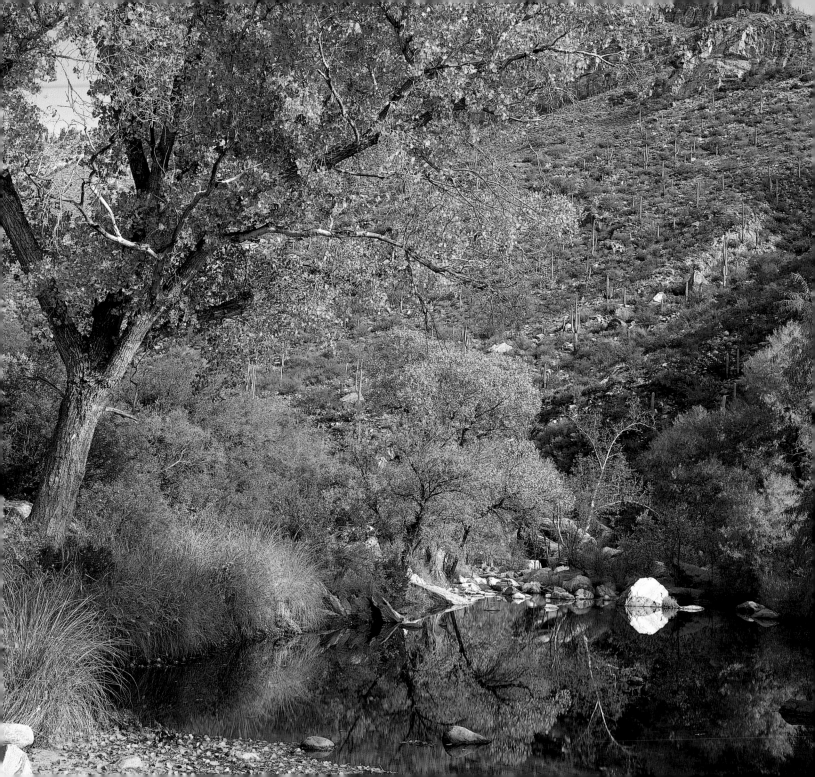

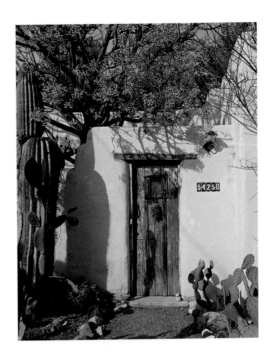

Left: This home is located in the historic Fort Lowell district, the site of the former 1879 Fort Lowell.

Far left: Cottonwoods and sycamore trees line Sabino Creek, which begins at 6,000 feet and winds through the rocky Sabino Canyon for ten miles.

Below: The bronze sculpture *Yesterday is Tomorrow* was created by Betty Saletta and stands near the Museum of Art in downtown Tucson.

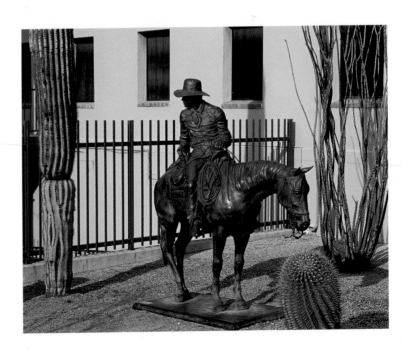

Right: Brittlebush wildflowers and young saguaros adorn the front of the visitor center at Saguaro National Park's west entrance.

Below: A bucking bronco tries to throw its rider at Tucson's Rodeo La Fiesta del los Vaqueros, which has grown from a four-day rodeo in 1925 to a nine-day celebration and is one of the top twenty professional rodeos in the country.

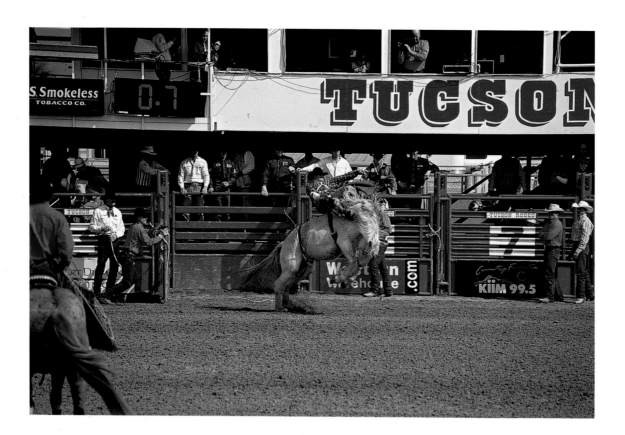

Left: Scenic Mount Lemmon Highway climbs through the upper reaches of Saguaro National Park to alpine country in Santa Catalina Mountains, nearly 8,000 feet in elevation.

Below: Brittlebush wildflowers and saguaro cacti line the Gates Pass Road in West Tucson Mountain Park, a 20,000-acre Sonoran Desert preserve.

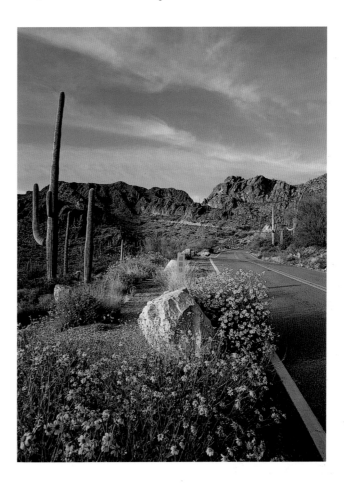

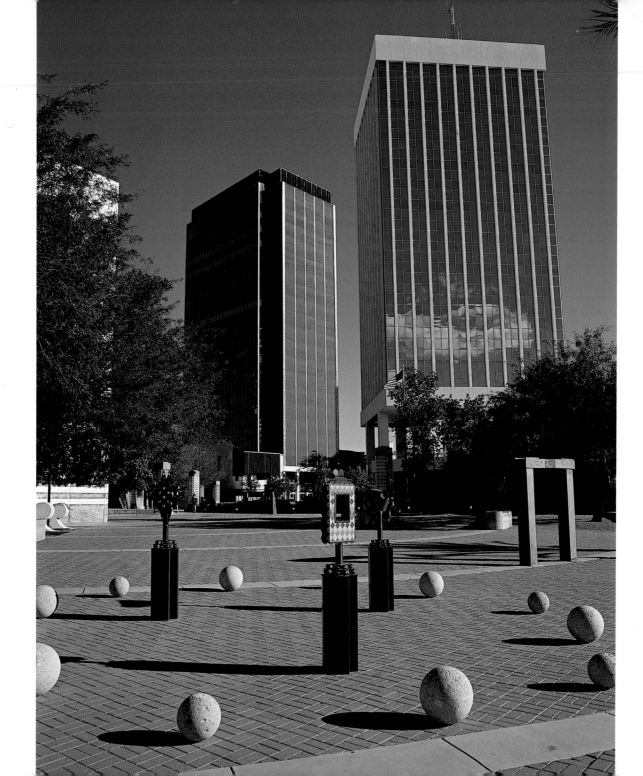

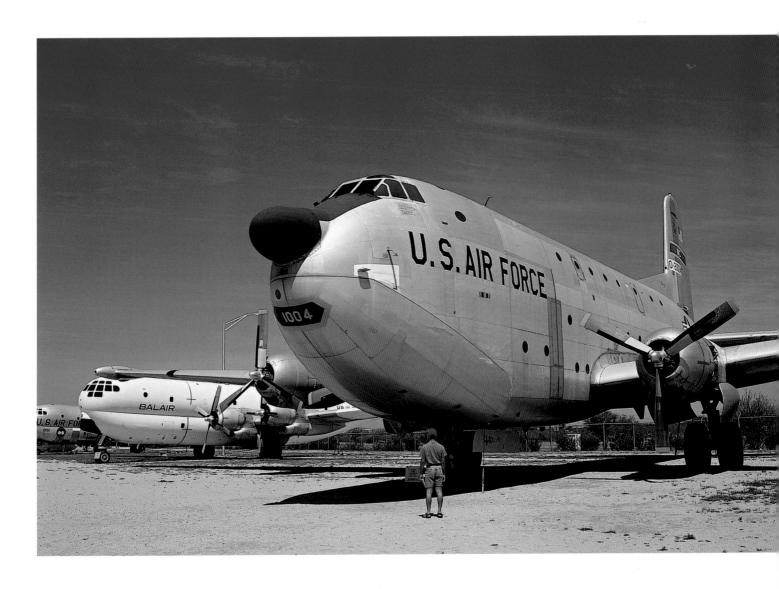

Above: These airplanes are part of the Pima County Air Museum, established in 1976, which has more than 200 aircrafts and 5 hangars.

Facing page: A far cry from its 1883 predecessor that opened in the upstairs of city hall, this main library plaza was redesigned in 2003.

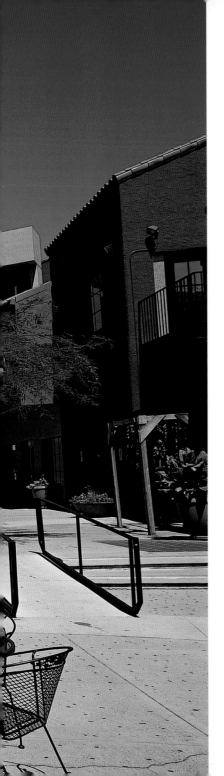

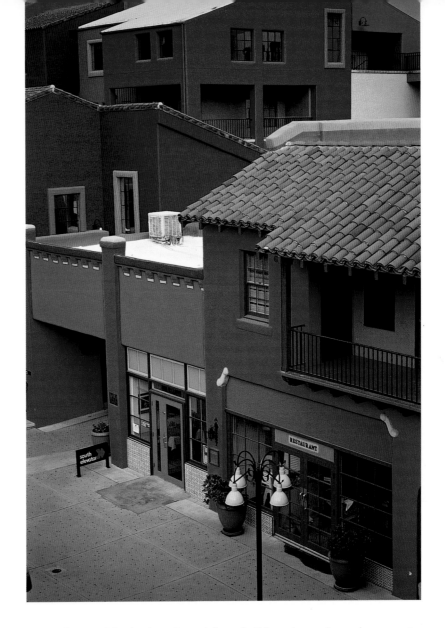

Above: The ten adobe, brick, and wood-frame buildings that make up downtown's La Placita Plaza—which means "little town square"—date back to the 1890s, but they were repainted in thirteen vibrant colors drawn from the surrounding Sonoran Desert. The paint was created especially for the project by the Sherwin-Williams Company.

Left: La Placita Plaza, Tucson's largest commercial office complex, houses businesses ranging from restaurants to retail shops.

Right: Against a backdrop of the Tucson skyline and the Santa Catalina Mountains, golfers putt on one of two Tom Fazio–designed golf courses at Loews Ventana Canyon Resort.

Below: Springtime blossoms on the giant saguaro cactus bear fruit that is eaten by animals, including white-winged doves and lesser long-nosed bats. The Tohono O'odham Indians also collected the fruit to make wine, jelly, and candy.

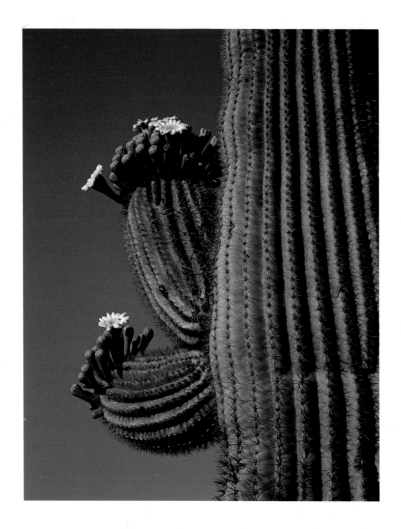

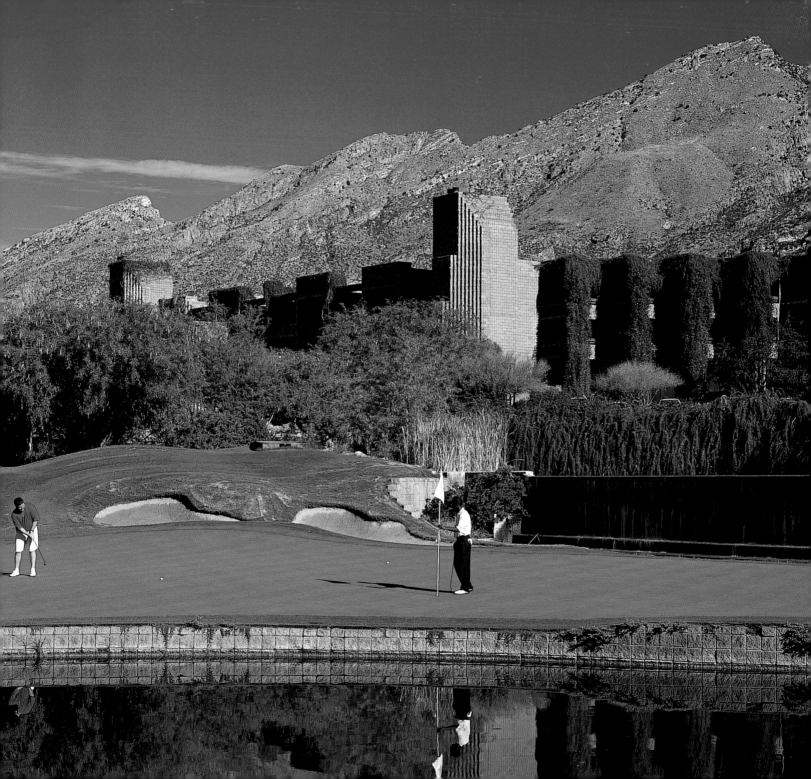

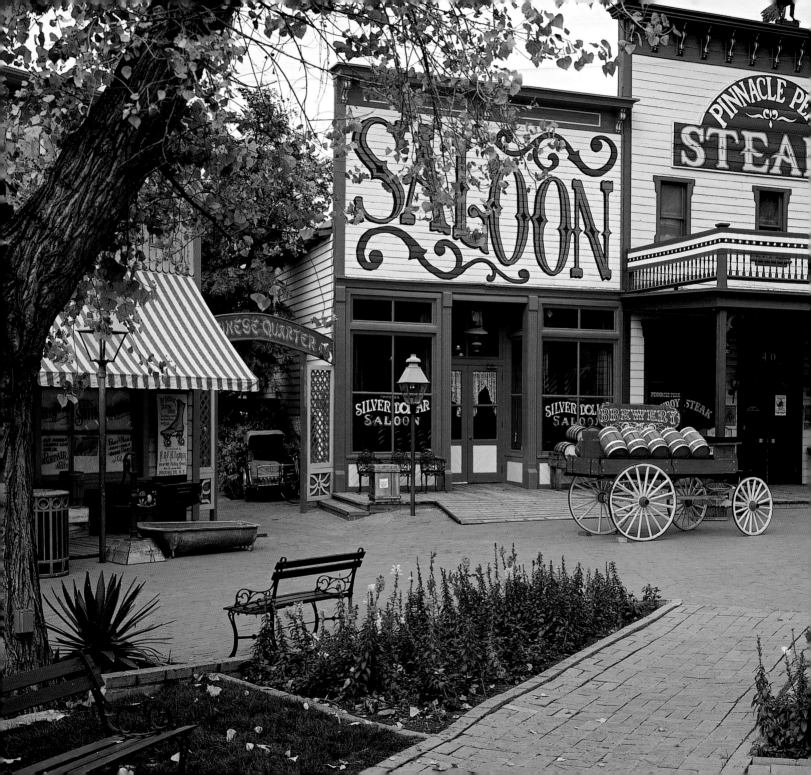

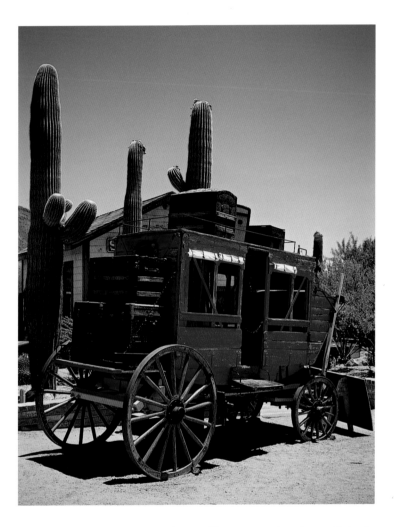

Above: This stagecoach is on display at Old Tucson Studios. Originally built for the 1939 movie *Arizona*, the studio was destroyed by an arson-caused fire in 1995, but many of the studio buildings have been rebuilt.

Left: A saloon in Trail Dust Town, a re-creation of a Western town that features a Wild West show, military museum, carousel, and a miniature train.

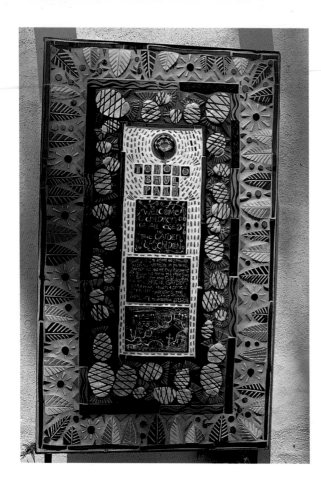

Above: This ceramic tile mosaic is one of a number of public art displays in Tucson.

Facing page: Sonora is a metal sculpture created by David Black that stands in front of the Joel D. Valdez main library plaza. Black describes the piece as "protoarchitecture" that explores the relationship between architecture and sculpture.

Below: La Pilita Youth Resource Center is graced by this mural painted by Martin Morena.

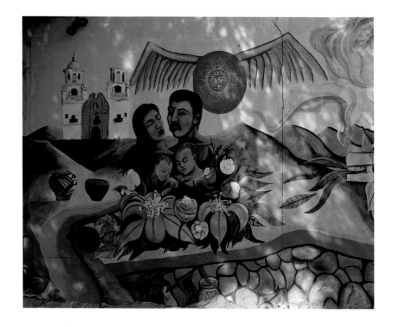

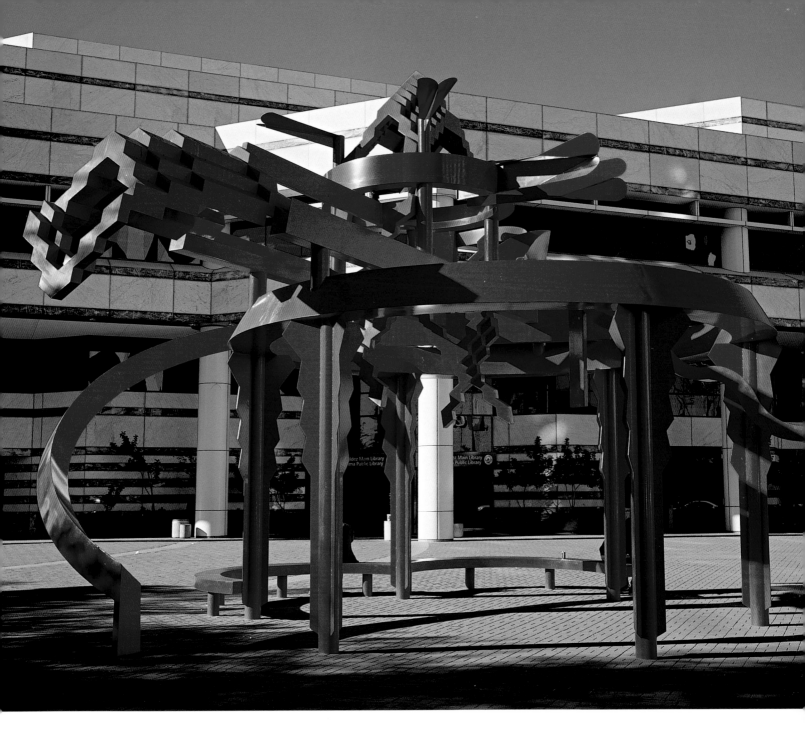

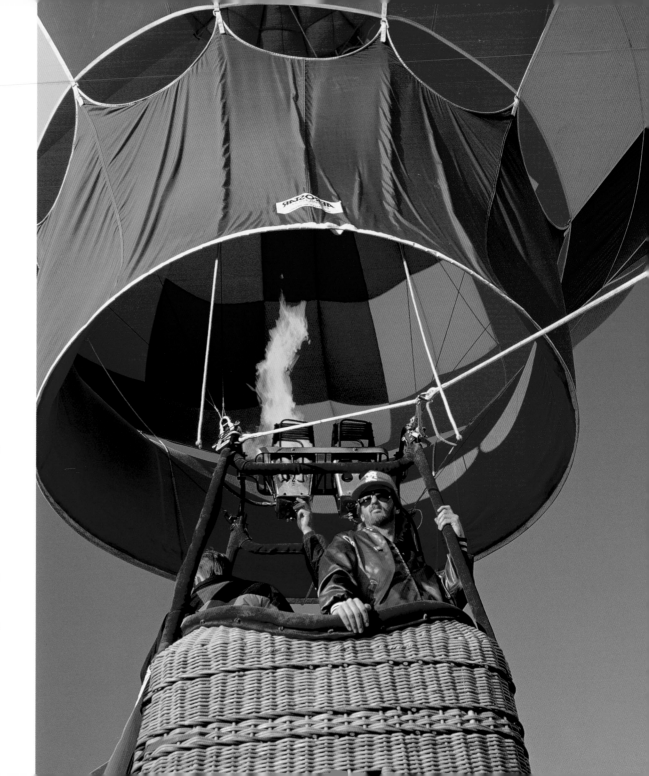

Right: This hot air balloonist launches into the desert skies over Tucson.

Facing page: During Tucson's annual Family Arts Festival, dancers from Conjunto Folklorico Mexico Mestizo perform on the Sister Cities stage in El Presidio Park. In partnership with the Sister Cities Association in the Global Village, the festival features six stages of entertainment in downtown public spaces and more than 100 artists.

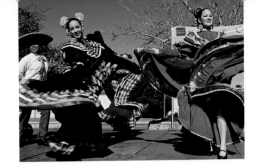

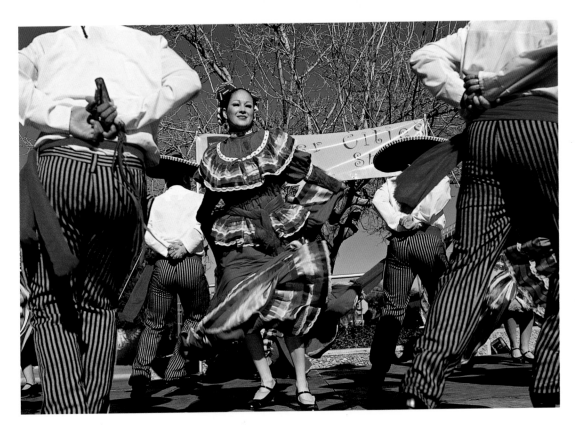

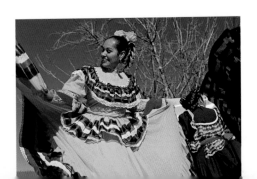

Left: Located in the downtown historic district, this adobe home features classic Southwestern architecture of the mid-1800s.

Facing page: Tucson's historic downtown railroad depot is undergoing a $26 million renovation to restore the depot to look as it did in 1941. The depot will house a transportation museum as well as the historic steam locomotive No. 1673.

Below: Chile peppers frame a doorfront in the artist community of Tubac, south of Tucson.

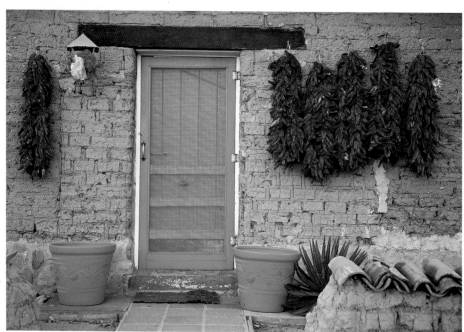

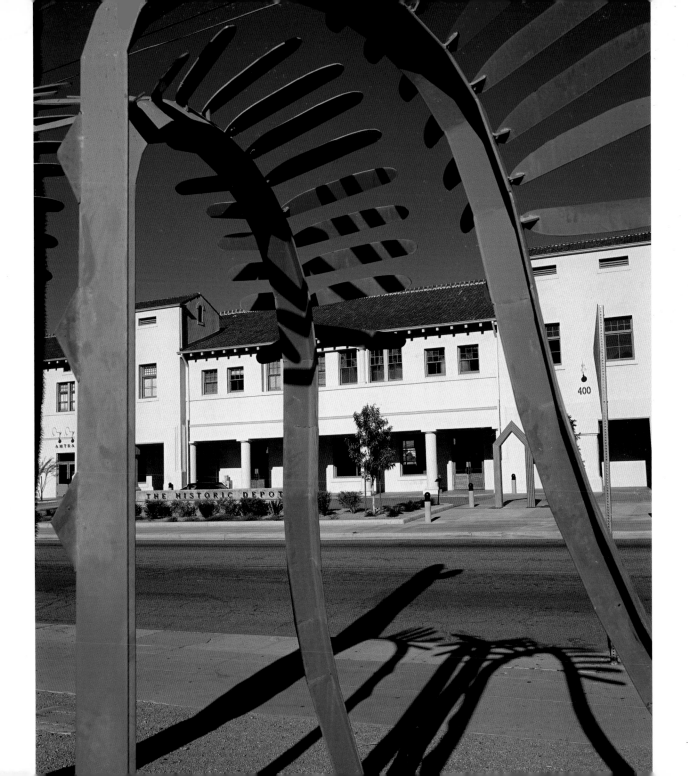

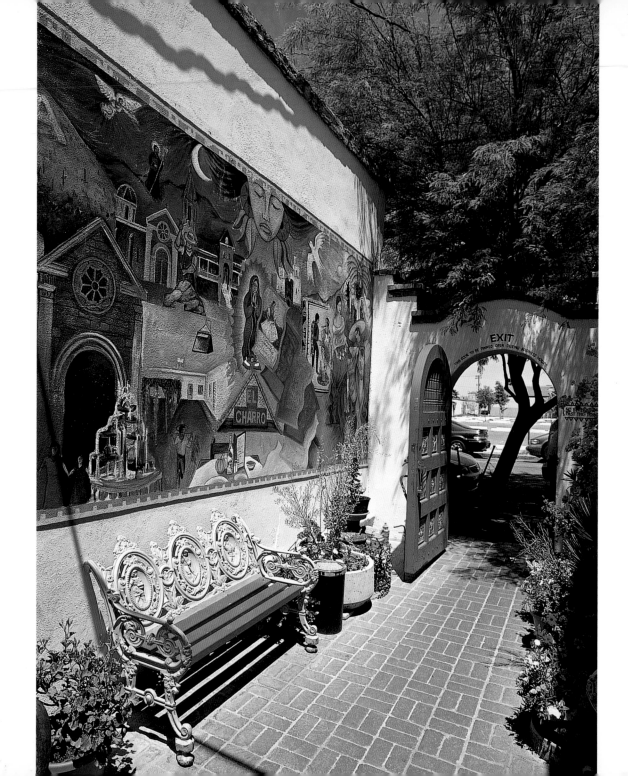

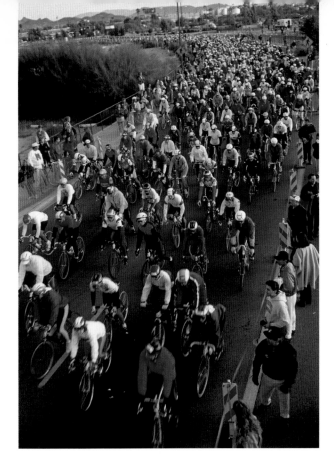

Above: The El Tour de Tucson features bicycle races that launch from various locations in town and are 35 to 109 miles long. EDWARD McCAIN

Facing page: This colorful mural by David Tineo graces the walls of El Charro Mexican Restaurant. The restaurant features traditional Sonoran Desert cuisine as well as innovative Tucson-style Mexican food.

Below: Elegant and bright, these intricate mosaic arches line the Santa Cruz River Parkway.

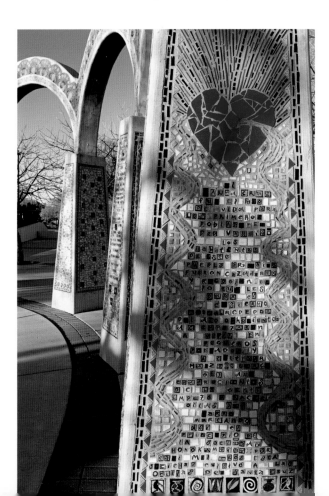

Right: These ancient Indian petroglyphs are located near the Signal Hill picnic area along the scenic Bajada Loop Drive, on the western edge of Saguaro National Park.

Below: In springtime, brittlebush blossoms greet visitors to Saguaro National Park.

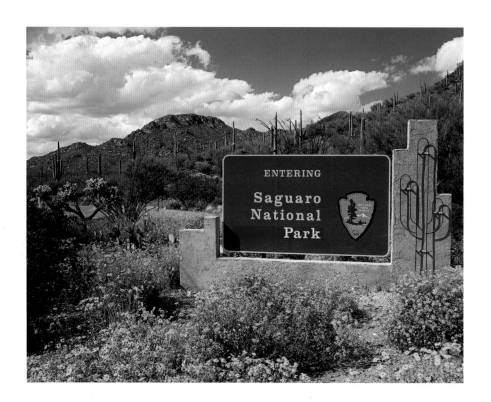

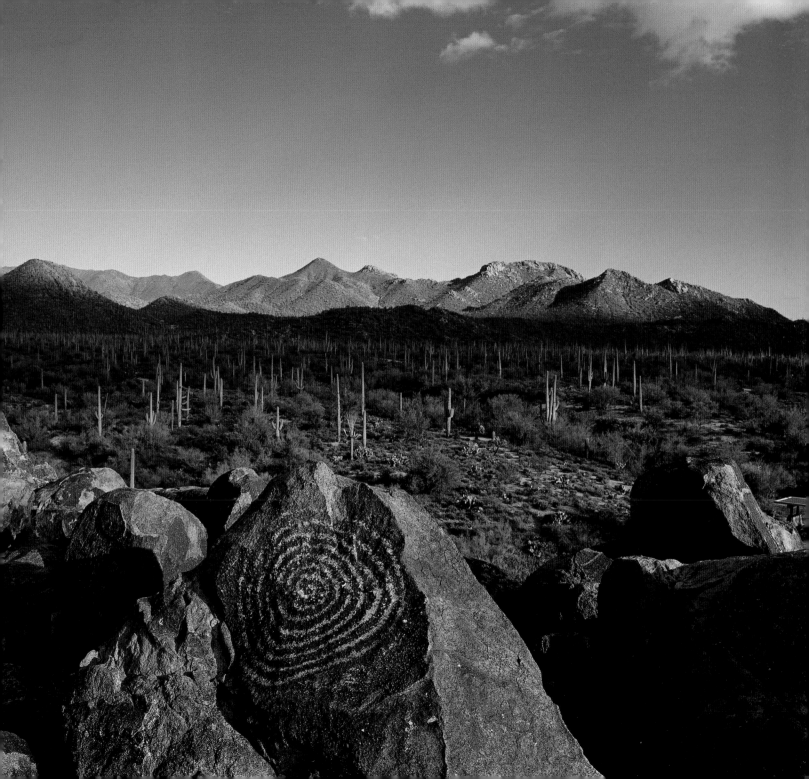

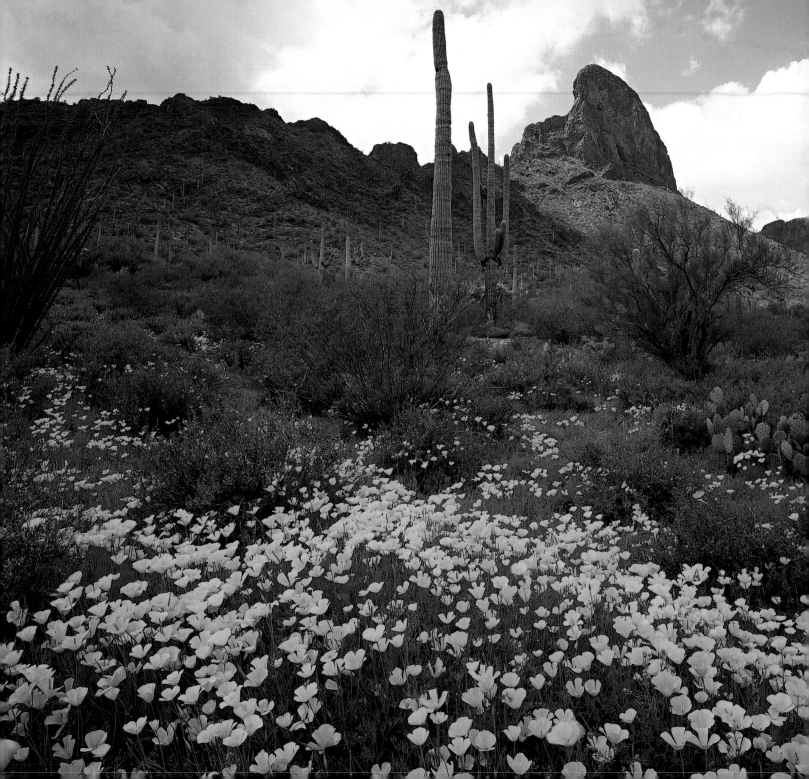

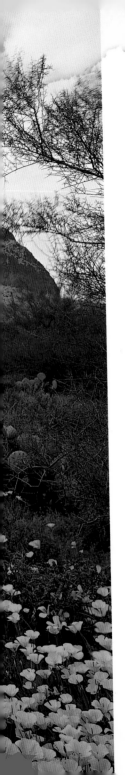

Left: Mexican poppies bloom among the saguaro cacti in the 5,500-acre Picacho Peak State Park.

Below: Springtime brings prickly pear cactus blossoms to Saguaro National Park.

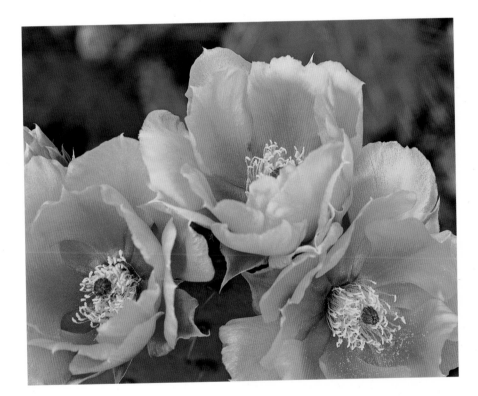

James Randklev

Master landscape photographer James Randklev has photographed America for thirty years, primarily with a large-format camera that provides the rich images collected in this volume. His brilliant and sensitive work has made him one of the Sierra Club's most published photographers. His color photographs have appeared in books, periodicals, calendars, and advertising—and they have been exhibited in the International Exhibition of Nature Photography in Evian, France. In 2003 Randklev was selected to be included a book entitled *World's Top Landscape Photographer—and the Stories Behind Their Greatest Images* by Roto Vision Publications, London, England. Randklev's photography books include *In Nature's Heart: The Wilderness Days of John Muir; Georgia: Images of Wildness; Wild and Scenic Florida; Georgia Impressions; Georgia Simply Beautiful; Olympic National Park Impressions; Florida Impressions; Florida Simply Beautiful; Arizona Impressions* and *Bryce Canyon National Park Impressions.*

More of James Randklev's imagery can be viewed at www.JamesRandklev.com